Winnipeg West

Painting and Sculpture in Western Canada 1945-1970

Exhibition organized by
Christopher Varley
for
The Edmonton Art Gallery

Itinerary

The Edmonton Art Gallery Edmonton, Alberta	September 2 · October 10, 1983
Surrey Art Gallery Surrey, B.C.	October 20 · November 13, 1983
Rodman Hall Arts Centre St. Catharines, Ontario	December 2, 1983 · January 1, 1984
Sarnia Public Library and Art Gallery Sarnia, Ontario	January 13 · February 5, 1984
Art Gallery of Hamilton Hamilton, Ontario	February 16 · March 18, 1984
Art Gallery of Windsor Windsor, Ontario	July 22 · August 19, 1984
Glenbow Museum Calgary, Alberta	September 14 · October 28, 1984

Acknowledgements _____

Winnipeg West took three years of on-again, off-again work to pull together. During that time I had the great pleasure of interviewing and corresponding with artists, administrators, and interested parties in all parts of Canada. These included Alvin Balkind, Alistair Bell, Ronald Bloore, Bruno and Molly Bobak, Eli Bornstein, Reta Cowley, Fred Douglas, Ivan Eyre, Brian Fisher, H.G. Glyde, Ted Godwin, Les Graff, Donald Harvey, Donald Jarvis, Illingworth Kerr, Kenneth Lochhead, Arthur McKay, Al and Colleen McWilliams, Janet Mitchell, Michael Morris, Douglas Morton, Wynona Mulcaster, Otto Rogers, Jack Shadbolt, Gordon Smith, George Swinton, Elizabeth Varley, and Esther Warkov. Additional documentary material came from the libraries of The Edmonton Art Gallery, The Vancouver Art Gallery and the Winnipeg Art Gallery, the archives of Glenbow Museum and the Mendel Art Gallery, and the exhibition and correspondence files of the Norman MacKenzie Art Gallery.

I would like to express my sincere thanks to the individuals and institutions named above, as well as to the collectors who so generously loaned their artworks to this travelling exhibition. I am also indebted to Doris Shadbolt, who came up with the title *Winnipeg West*, and to The Canada Council, which provided the Special Exhibition Assistance for this project. Although the Council's role is not discussed in the essay that follows, the effects of its disinterested patronage have been felt throughout the West. Much of the artistic upsurge of the '60s can be attributed to it.

Finally, I would like to thank the staff of The Edmonton Art Gallery for their assistance with this major project. Brenda Banks, Maggie Callahan, Monty Cooper, Kate Davis, Normand Dutrisac, Terry Fenton, Eleanor Lazare and Deborah Witwicki all played important roles in its research and production.

C.V.

Cover:

Lionel Lemoine
FitzGerald
Geranium and Bottle,
1949
oil on canvas
45.6 x 30.1 cm.
Collection of The Winnipeg
Art Gallery

Preface

Winnipeg West is the first exhibition to attempt to account for the spread and development of art in western Canada after the Second World War. The cut-off date of 1970 brings it very close to the present. At one time we considered calling the exhibition *A Tale of Six Cities* because the art of the period was an urban phenomenon, and was heavily dependent upon personal exchanges and travel between the widely separated cities of British Columbia, Alberta, Saskatchewan, and Manitoba. Like the London and Paris of Charles Dickens' tale, Vancouver, Edmonton, Calgary, Regina, Saskatoon and Winnipeg each had its own character and 'scene'. Western Canada was never a homogeneous cultural block.

Although this is not a study of modernist art *per se*, all of the art discussed falls within the various traditions of modernism. We may therefore learn from it something about the ways in which western Canadian artists have perceived the world, and coped with their isolation. And we will certainly learn something about the nature of modernism *in* isolation.

The *raison d'être* of this undertaking, however, is to draw attention to the many aspects of post-war western Canadian art. Although most of the artists' names are familiar by now, we still do not have a discriminating understanding of the contributions of many of them, and we continue to think of most of them in isolation. I hope that this study leads to further interest in these artists, and to a deeper understanding of their achievements and importance to one another.

Contents

Next page:

Jack Shadbolt
Marpole Street Bridge,
1945
pencil and watercolour on paper
70.5 x 54.9 cm.
Collection of The College of Physicians and Surgeons of B.C., Vancouver

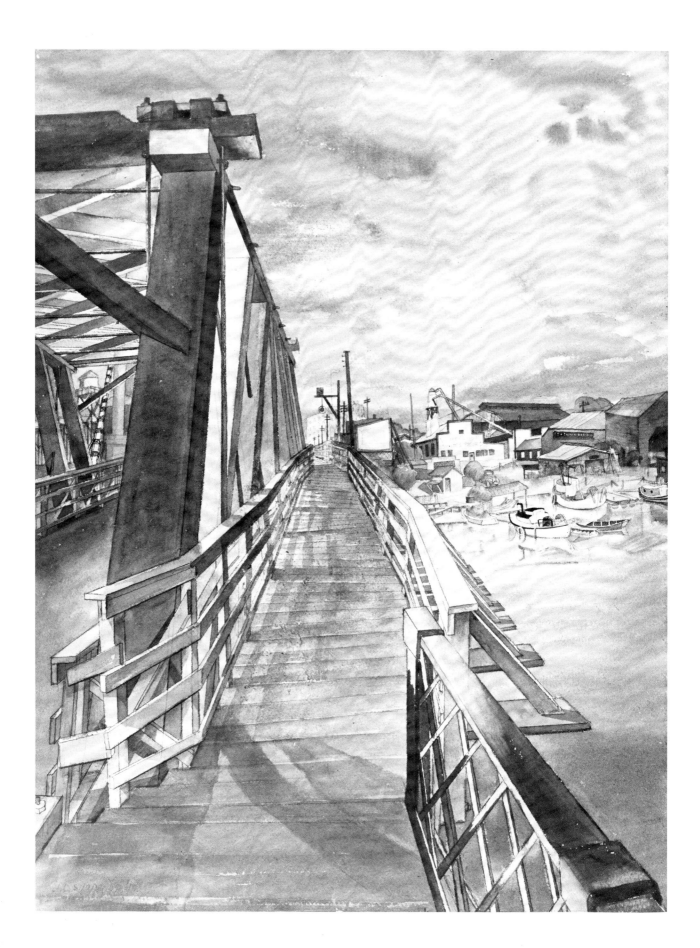

Ecole du Pacifique
Vancouver, 1945-1960

O ur tale begins in Vancouver,[1] which enjoyed more prestige and acclaim than the other five western Canadian cities for nearly the entire period covered in this survey. Its status was recognized in the Canadian exhibitions that travelled abroad, the pages of *Canadian Art*, and by the other five cities. When H.G. Glyde resigned as head of the Department of Art at the Provincial Institute of Technology and Art in Calgary in 1946, he invited J.W.G. ('Jock') Macdonald of Vancouver to take his place. Likewise, Joseph Plaskett of Vancouver replaced Lionel LeMoine Fitz-Gerald as Acting Principal of the Winnipeg School of Art for 1947-48.[2] And when Kenneth Lochhead re-organized the Emma Lake workshops in Saskatchewan in 1955, he did not turn to eastern Canada or to The United States for workshop leaders, but to Vancouver: Jack Shadbolt led the session that first summer, and Plaskett followed in 1956. Also, B.C. Binning and Shadbolt served on the juries for the prestigious *Winnipeg Show* in 1956 and 1957, respectively.

Furthermore, many prairie artists were attracted to Vancouver. W.L. Stevenson, Maxwell Bates' early ally in Calgary, lived in Vancouver from 1946 to 1953, while working for the Canadian Pacific Railway. Bates, himself, moved permanently to nearby Victoria in 1962. Illingworth Kerr taught at the Vancouver School of Art from 1945 to 1947. There he befriended Gordon Smith who, after suffering injuries in the war, moved to Vancouver instead of back to Winnipeg, where he had studied under FitzGerald and worked as an illustrator at Brigden's. Claude Breeze and Brian Fisher left Regina College on their teachers' advice in 1959 to complete their studies at the Vancouver School of Art. Roy Kiyooka, one of those teachers, followed them in 1960 to take a position at the same school. And Iain Baxter ended his journey of study that had begun in Calgary, in Vancouver in 1964.

But what, besides the scenery and climate, made Vancouver so attractive? Existing cultural and educational institutions were certainly a factor, for through the work of The Vancouver Art Gallery and Vancouver School of Art, something akin to traditions and

1) Vancouver's population was 244,833 in 1951, making it the largest city in Western Canada.

2) Or was it 1948-49? Improbable as it seems, there is some confusion about when Plaskett was in Winnipeg. Doris Shadbolt records that he was there in 1947-48 ("Joe Plaskett — An Ode to a Room", *Canadian Art*, Vo. XIII, No. 4, summer, 1956, p. 318), but the Architecture and Fine Arts Library of The University of Manitoba records that he was there in 1948-49 (Peter Anthony to Christopher Varley, June 2, 1983).

B.C. Binning
*Fanciful Seascape in
Primary Colours*, 1949
oil on board
81.3 x 111.8 cm.
Collection of the Sarnia
Public Library and Art
Gallery. Gift from the C.S.
Band Estate

B.C. Binning
Picnic Ashore, August 11,
1944
ink on paper
45.7 x 61 cm.
Collection of Mrs. B.C.
Binning, West Vancouver

tolerance of the visual arts had been established. Two major figures, Emily Carr and F.H. Varley, had already left their marks on the province, and Lawren Harris added new life to the city when he moved there in 1940. Having adopted abstraction in the mid-'30s, Harris encouraged Jock Macdonald and B.C. Binning in their forays into this new frontier of expression. And as Chairman of the Exhibition Committee of The Vancouver Art Gallery in the mid-'40s and, later, as a member of the Gallery's Council, he promoted an adventurous exhibition program and close ties with the Vancouver School of Art.

One of the most intriguing results of this collaboration was the Gallery's *Art in Living* exhibition of September 1944, "Organized by a group of young artists under the direction of Mr. Fred Amess (principal of the art school)...designed to show the people of Vancouver what might be achieved in the future by careful planning of our city and of the homes it will contain."[3] Binning, who taught drawing and architecture at the art school, arranged the architectural component of this exhibition. Starting with his own home in West Vancouver, built about 1940, he introduced Frank Lloyd Wright derived modernist architecture to the Coast. The 'post and beam', flat-topped style that later won wide acceptance in Vancouver owes a lot to him.

But in the mid-'40s Binning was also known as a pen-and-ink virtuoso. His whimsical depictions of the coves and beaches of West Vancouver spoke of the pleasures of life on the Coast. They had much in common with Dufy's and Matisse's genteel visions of the French Riviera, and revealed a delightful sense of the ridiculous. Donald Jarvis was so impressed with the wit and facility of these works that he decided to become an artist after seeing one of Binning's classroom demonstrations. His own pen-and-ink drawings of the later '40s owed something to Binning's vision.

The other major figure at the Vancouver School of Art was Jack Shadbolt. A controversial teacher who raised the pitch of art school polemics, he countered Binning's amused detachment with art that was outspoken, engaged, and steeped in the anxiety of the age. Although he moved quickly towards abstraction after the war, some of his most remarkable paintings were the city street scenes that he recorded in watercolour between 1942 and 1946. These affirmations of his attachment to Vancouver were as frank as they were affectionate, and often included superb passages of atmospheric washes.

3) *President's Report*, Vancouver Art Gallery, 1944-45

Lawren Harris
Untitled, c. 1951
113.5 x 145.5 cm.
oil on canvas
Collection of The Edmonton
Art Gallery. Purchased with
funds donated by the
Women's Society, 1982

Jack Shadbolt
Dark Fruition, 1952
ink and casein on paper
67.3 x 89.5 cm.
Collection of the Seattle Art
Museum. Northwest Annual
Purchase Fund

Donald Jarvis
The Street, 1952
watercolour on paper
24.8 x 18.3 cm. (sight size)
Collection of the artist, West
Vancouver

Most of Vancouver's painters looked to Britain or to the American West Coast for artistic leadership after the war. The Vancouver Art Gallery undoubtedly reinforced the interest in British art with its well-chosen purchases of paintings by Graham Sutherland, Ben Nicholson, Ivon Hitchens, and others.

Although Lawren Harris did not respond to these new works himself, he also helped to clear the way for abstraction through his own enthusiastic commitment to it. A devout Theosophist, he held the utopian view that a universal reality of harmonious order existed beyond the chaotic world of temporal appearances. He developed a symbolic abstract language of his own through which he tried to bridge the gap between the universal and the particular, and while he seems to have been possessed during the '40s by dull, geometric formulas, he burst into the next decade and the age of retirement with more energy and fireworks than any other Vancouver artist. Propelled by buoyant feelings of spiritual exaltation, he painted some beautifully crafted and highly individual — some might say eccentric — canvases that alluded to the mountains, waves, and vistas of the Coast.

Binning and Shadbolt were much younger than Harris, and clearly influenced by the new British art. Binning, who befriended Henry Moore while studying in England just before the war, looked as hard at Ben Nicholson as at Paul Klee and Joan Miró when he started painting abstractions in 1948. He borrowed Nicholson's device of roughing up the surfaces of his paintings on masonite, and adopted the British painter's playful method of superimposing planes and destabilizing spatial relationships. Although the results tended to be repetitive and lightweight, the gaiety of these paintings suggests once again that Binning had found a bit of the Mediterranean on the West Coast.

By comparison, Shadbolt's vision was sombre and perhaps more apt. He saw the sodden reality of Vancouver, with its opaque grey light, months of drizzle, and tangled profusion of growth. But, like many artists of the time, he seemed to trade art for 'ambition' when he turned to abstraction in the late '40s. As fine as his 'metamorphic' abstractions often were, they lacked the tender insights of his Vancouver street scenes. Many were indebted to Graham Sutherland, whose paintings were filled with mechanical

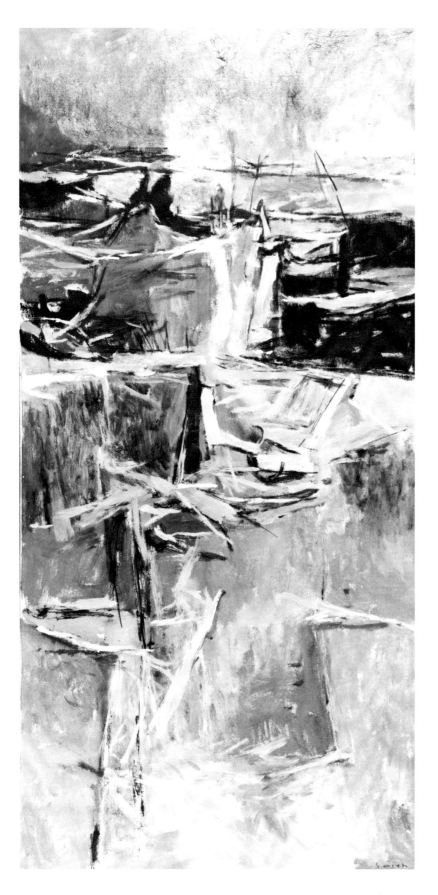

Gordon Smith
*Tidal Basin (Vertical
Landscape)*, 1958
oil on canvas
121.3 x 66 cm.
Collection of The Edmonton
Art Gallery. Gift of Dr. and
Mrs. K.A.C. Clarke, 1961

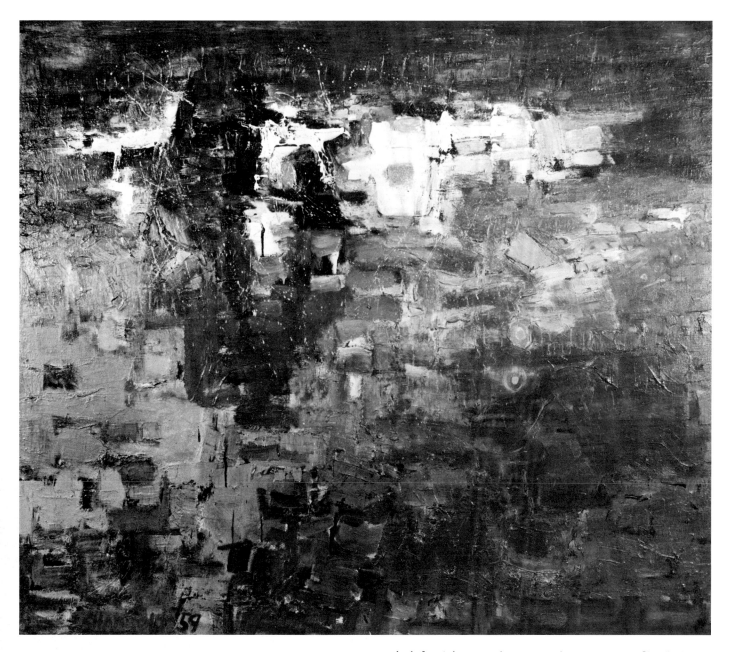

Jack Shadbolt
Swamp Gold, 1959
oil and lucite 44 on canvas
114.3 x 135.3 cm.
Collection of the Gallery/
Stratford

symbols for violence and metamorphosis in nature. Shadbolt, and then Jarvis, adopted the English painter's spirals and spikes. As in Sutherland's paintings, the results all too often looked melodramatic, as if the post-war art world was still hung-over from too much violence, too much despair, and too much Picasso.

In 1958 Shadbolt won the Canadian Section Award at the Carnegie International Exhibition in Pittsburgh. This brought him attention from abroad, and earned him acclaim in Canada. By this time he favoured oil paints over watercolour, and his paintings of the period were generally influenced by the late-cubist abstractions of Hans Hofmann and Nicholas de Stael. The acidic brilliance of his palette certainly owed something to Hofmann.

The influx of students to the Vancouver School of Art after the war was so great and so sudden that some were quickly advanced to teaching positions, and others stayed on to teach after graduation. Donald Jarvis and Gordon Smith were among these. Bruno

Bobak, who received his early training from Carl Schaefer in Toronto, joined the staff in 1947.

Jarvis was one of several Vancouverites who studied with Hans Hofmann in New York in the late '40s. Upon returning home, he turned to the rain forest and city streets for subjects. Initially indebted to Shadbolt, he tried to integrate cubist figures into naturalistic settings. While his paintings of the early '50s were gloomy — coloured by the sentimental naivety of youth — by the late '50s, he had grown into a finely discriminating and responsive painter. His abstractions of the period combined atmospheric colour and figurative elements in a lyrical and evocative dance.

Smith also benefitted from Shadbolt's advice and example, and helped to establish Vancouver's national reputation when he won first prize at the *1st Canadian Biennial*, organized by The

National Gallery in 1955. But he constantly changed styles, and seems to have been lionized as much for his lifestyle as for his achievements. Whether alluding to Rufino Tamayo, or to the 'lyrical abstraction' of Ivon Hitchens, he always painted with discrimination and refinement.

Much the same can be said of Joseph Plaskett, whose pastel landscapes and darkened interiors reflected a chic 'French' sensibility. Although he spent most of his time in Paris, Plaskett maintained close ties with artists and collectors in Vancouver, who seemed to have regarded him with a certain amount of envy and awe.

This fascination with style and social acceptance was both a blessing and a curse. It brought the artists public attention, and helped to sell their work. But all the talk of a Vancouver 'scene' also

Opposite page:

E.J. Hughes
Howe Sound, B.C., 1955
oil on canvas
76 x 64 cm.
Collection of The Edmonton
Art Gallery. Gift of Dr. Max
Stern, 1982

Donald Jarvis
Red Figure Variation,
1965
oil on canvas
152.3 x 119.5 cm.
Collection of the Art Gallery
of Greater Victoria. Elizabeth
Marshall Bequest

Joseph Plaskett
The Mirror, 1955
oil on canvas
91.9 x 72.7 cm.
Collection of The Edmonton
Art Gallery. Gift of Mrs. H.A.
Dyde Purchase Fund, 1956

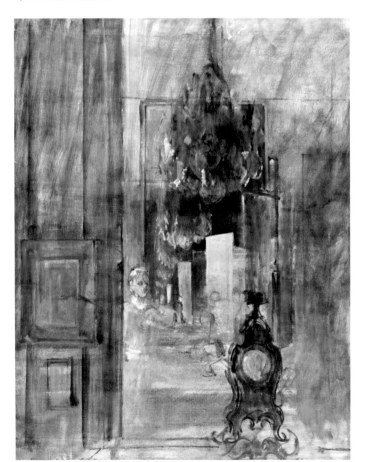

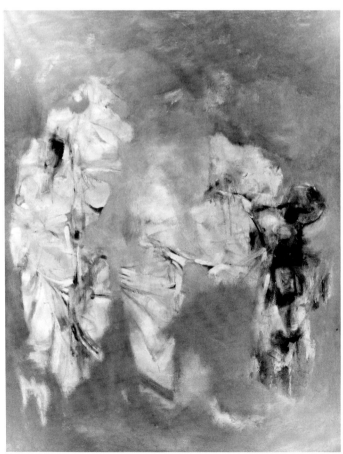

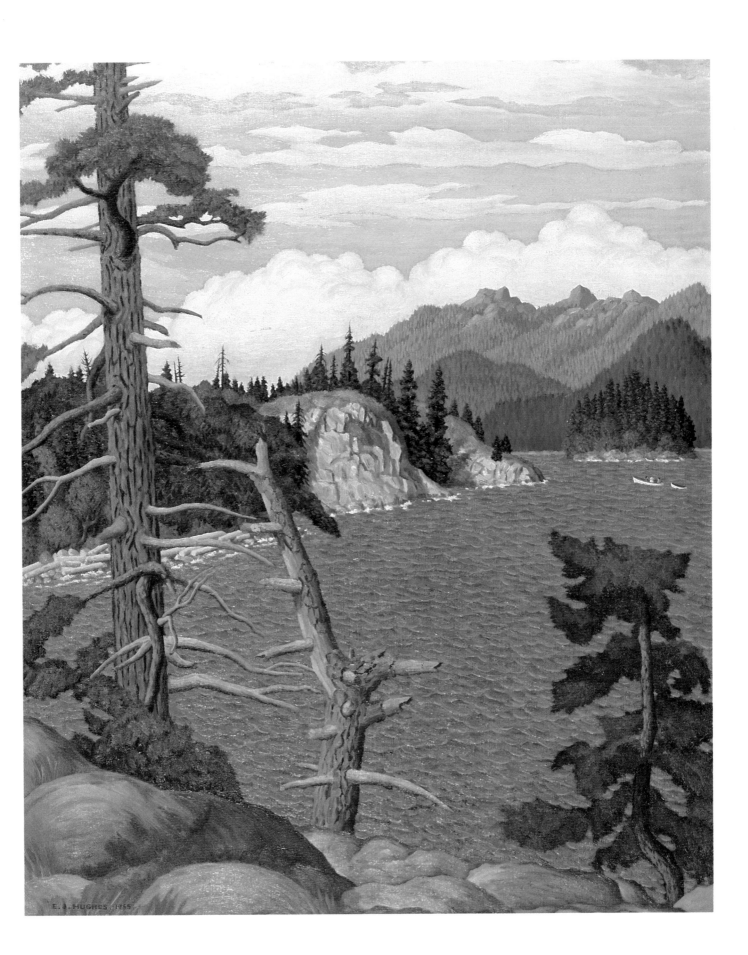

Bruno Bobak
Vancouver Harbour,
c. 1959
charcoal on paper
48.2 x 127 cm.
Collection of The Edmonton
Art Gallery. Purchased in
1983.

created confusion and led to self-consciousness and entrench-ment. Bruno Bobak felt so bitter about the results that he eventually decided to move:

> *I grew to hate the attitude that you measured the quality of an artist by the possessions he owned. There was always a scram-ble to see who could outdo somebody else: the chic wife, the beautiful house...eventually it was a question of whether you had a twelve foot sailboat or a fourteen foot sailboat. If you had two sailboats you were twice the artist of someone who had just one. It was a kind of raw, monied life. Nobody ever really talked about art. You just talked about the good life.[4]*

Not unexpectedly, this anger was reflected in Bobak's own art of the late '50s. After paying the customary homage to British artists like Paul Nash and John Piper, and looking closely at the American West Coast painter Morris Graves, he turned to pre-war European expressionism, especially to the panoramic cityscapes of Oscar Kokoshka. The biting charcoal drawings that followed were filled with sweeps and scrawls. Busy and melodramatic, yet also dense and full, they greatly enhanced his reputation as a graphic artist.

Vancouver was not as cosmopolitan or 'in the know' as R.H. Hubbard, Allan Jarvis, and other visitors from the East seemed to think. In hindsight, we can see that they should have given more attention to Montreal. And it should be clear that in settling for such

a comfortable position on the rear deck of the official post-war avant-garde, Vancouver's artists were likely to grow complacent. They would have been better off with less recognition and more criticism.

One final word though, for the isolation and spongy intellectual climate of provincial art centres is not always a disadvantage. Highly independent or visionary artists, who create their own histo-ries or who might be crushed in a more competitive environment, may actually thrive in such an atmosphere.

The most important of British Columbia's 'independents' was E. J. Hughes, who was trained in Vancouver, and lived on Van-couver Island. His 'picture postcard' landscapes of the '40s and '50s were among the most guilelessly original and pictorially accomplished paintings made on the Coast. They displayed real insights into both the province's Mediterranean charms and its darker, primeval undertones. And he somehow managed to hold them together, although most were painted in saturated, strongly contrasting colours. It seems ironic that Hughes, who cared so little for recognition or success, is now the most sought after West Coast painter of the post-war period.

4) Andrus, Donald F.P.; *Bruno Bobak: Selected Works, 1943-1980* (exhibition catalogue), Sir George Williams Art Galleries, Concordia University, Montreal, 1983, p. 55

What's Wrong with Winnipeg?
1945-1970

O f all the cities in the West, Winnipeg[1] would appear to have enjoyed the most historical advantages. It was the 'gateway' to the region, and the site of the first permanent settlement. Somewhat more sophisticated than other western communities, it opened a public art gallery eleven years before Edmonton, and nearly twenty years before Vancouver did. One of the artists represented in the gallery's inaugural exhibition of December 1912 was Winnipeg born Lionel LeMoine FitzGerald who has been recognized as a major figure in Canadian art since 1930.

But Winnipeg has produced few such artists, and it has always projected a cloudy image to the rest of the country. Even the nationally acclaimed *Winnipeg Show*, organized by The Winnipeg Art Gallery, annually between 1955 and 1961, and biennially between 1962 and 1970, failed to establish the city on the visual arts map. Perhaps this was because, while the gallery devoted time and attention to this national survey, it was perceived to be aloof from the local art community. LeMoine FitzGerald and Ivan Eyre were practically the only artists to receive its ongoing support and patronage.

The Winnipeg School of Art, which became affiliated with the University of Manitoba in 1950, offered the semblance of a context, and employed some influential teachers, but its relationship to the rest of the art community was never as strong as it might have been. Even during the two decades when FitzGerald was the principal, it never held a clear position of leadership.

Yet FitzGerald was unquestionably the most widely-recognized artist working in the city at the end of the war. He was curious and perceptive, albeit cautious, and his still-lifes of that time were among his finest achievements. Many of these drawings, watercolours, and oil paintings employed the simple, yet dynamic formula of setting vertical forms against diagonal planes. Like Cézanne's paintings, most were asymmetrically balanced, and as if in homage to Cézanne, FitzGerald placed apples in many of them.

FitzGerald also practised abstraction from 1950 until his death, in 1956. He was encouraged to take it up by Lawren Harris, who he periodically visited in Vancouver during the '40s. The only clear influences that his abstractions revealed, however, were those of Lyonel Feininger and Russian-German constructivism. The proximity of the Chicago Bauhaus may have been a factor in determin-

1) Winnipeg's population was 235,710 in 1951 and 265,429 in 1961, making it the second largest city in Western Canada, but the slowest growing.

Lionel LeMoine,
FitzGerald
*Still Life with Flower
Pot,* 1949
watercolour on paper
38.7 x 56.5 cm
Collection of The
Edmonton Art Gallery.
Purchased in 1958

ing this, and we will see that artists in Saskatoon later looked to the same sources for models. But FitzGerald produced too little, too late to contribute anything to the acceptance or development of abstraction in Canada, and while the best of his abstracts transmitted some of his feelings for spirituality and 'pure' form, most were wistful, naive, and marred by spatial incongruities.

In 1950, a year after FitzGerald's retirement, William Ashby McCloy was hired from the University of Iowa as the first director of the reorganized University of Manitoba School of Art. This was but the first post-war link between Manitoba and then Saskatoon, and the American mid-west. In fact, McCloy brought two other University of Iowa graduates, John Kacere and Richard Bowman, with him to Winnipeg; and a third, Richard Williams, was hired to replace him when he returned·to The United States in 1954. Winnipeg does not

seem to have looked to eastern Canada at all for guidance. Nor did it look to its own artists and administrators, which may be another reason why it did not establish strong, ongoing traditions. Outsiders did not tend to stay long, and were not always accepted by, or interested in the art community.

Nor did their art 'stick'. While Douglas Morton still remembers the excitement raised by an exhibition of McCloy's, Kacere's, and Bowman's paintings in 1952 at Coste House in Calgary[2], it may now be impossible to find anything by the latter two artists in Winnipeg, and the Winnipeg Art Gallery only owns one painting by McCloy — a pastiche of a Picasso.

2) Douglas Morton in conversation with Christopher Varley, July 28, 1981

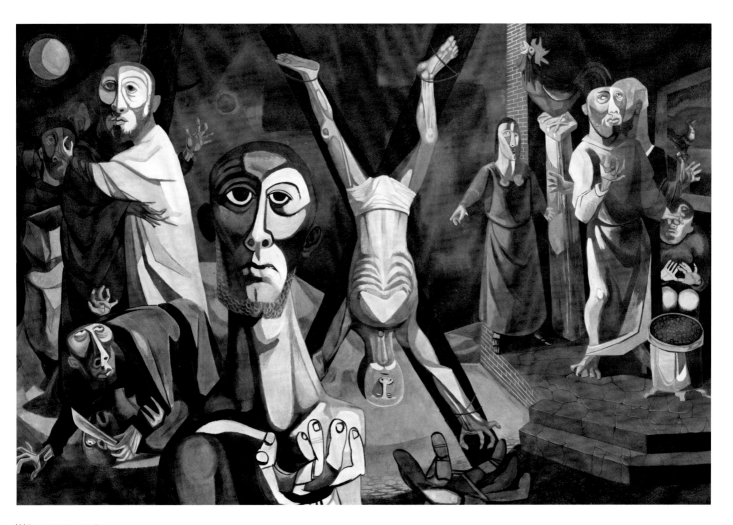

William Ashby McCloy
*And Peter Followed
Afar Off*, c. 1951
poster paint on canvas
mounted on plaster board
76.5 x 114.6 cm.
Collection of The Winnipeg
Art Gallery. Donated by The
Women's Committee

Nevertheless, Winnipeg received considerable regional attention during the '40s and '50s. Simply having an art school and a gallery were enough at the time, for they provided opportunities for advanced study, exhibitions, and employment. George Swinton, who served as the first curator of the Saskatoon Art Centre from 1947 to 1949, took a teaching post at the art school in 1954. Ivan Eyre had left Saskatoon the year before to continue his studies at the school.

Eyre recalls that Swinton and Robert Nelson, who McCloy brought to Winnipeg from the Chicago Art Institute School, were the two most influential teachers at the school in the mid to late '50s.[3] Swinton counteracted Nelson's Picassoesque surrealism with a personal form of romantic naturalism. He showed a propensity for hot colours, and however poor some of the results were, his

biblical paintings and landscapes were always *tours de force*.

He seems to have exerted an influence at the school similar to that of Jack Shadbolt in Vancouver, and is remembered either as broad minded and energetic or opinionated and condescending.

The art school produced its fair share of talented students, and appears to have been ahead of the rest of the community in terms of ambition, but many of its finest graduates left Winnipeg, and of those who stayed, few developed. Kelly Clark, for example, was looked up to by his fellow students. The Winnipeg Art Gallery bought two of his paintings from Winnipeg Shows, but he apparently stopped painting for several years in the early '60s in favour of a career in music.

3) Ivan Eyre in conversation with Christopher Varley, February 28, 1983

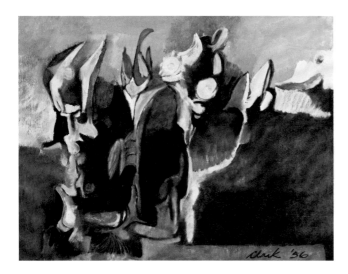

Clark, Kelly
Plants, 1956
oil on canvas
61.3 x 81 cm.
Collection of The Winnipeg
Art Gallery. Donated by Mr.
and Mrs. A.W. Mitchell

George Swinton
Birth of a Prairie River,
c. 1960
oil on canvas
81.5 x 122 cm.
Collection of The Winnipeg
Art Gallery. Donated by The
Women's Committee

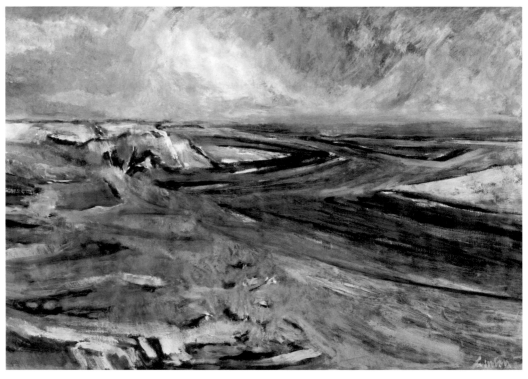

Other Winnipeg artists have quickly come and gone from the national scene over the years, including Jack Markell, a devotee of what Clement Greenberg called the "Boston school of Jewish expressionism",[4] and Esther Warkov, who studied at the art school in the late '50s, and received considerable praise and attention while her paintings were handled by Marlborough-Godard Gallery in Toronto and Montreal. But she dropped out of sight when this commercial gallery stopped representing her. This was unfortunate; her enigmatic, often witty, dream image paintings were highly individual. She greatly admired Jack Chambers of London, Ontario, and her early paintings often included floating objects and pale, close hued colours that were similar to his.

4) "Clement Greenberg's View of Art on the Prairies: Painting and Sculpture in Prairie Canada", *Canadian Art,* Vol. XX, No. 2, March/April 1963, p. 98

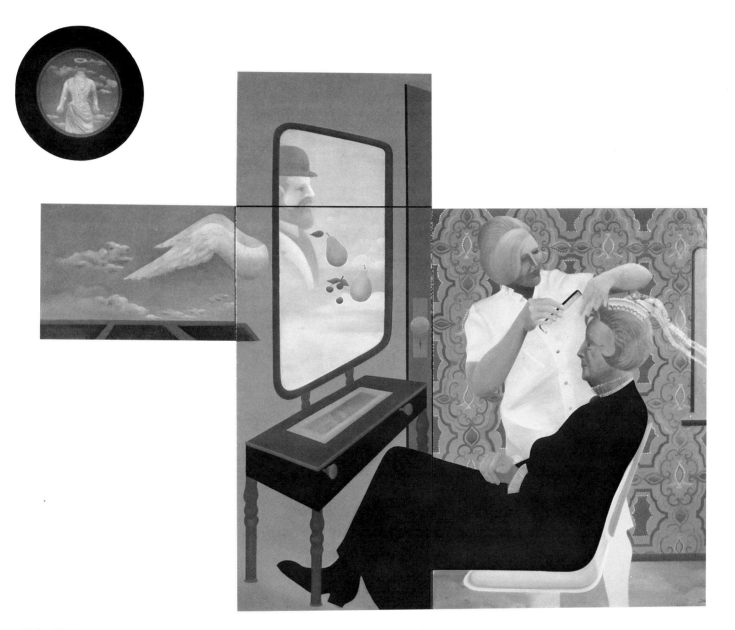

Esther Warkov
*Madonna of the Golden
Pears*, 1968
acrylic on canvas
122 x 158.2 cm.
Collection of the Mendel Art
Gallery, Saskatoon

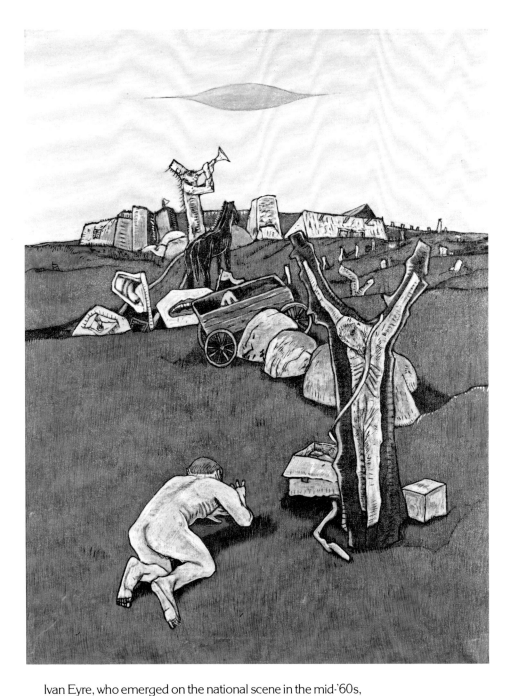

Ivan Eyre
Crucifixion, 1963
oil on canvas
85.8 x 55.7 cm.
Collection of the Mendel Art
Gallery, Saskatoon

Ivan Eyre, who emerged on the national scene in the mid-'60s, is unquestionably the most widely admired Winnipeg painter since FitzGerald. He has received ongoing support and recognition from the Winnipeg Art Gallery, and is respected by his fellow Winnipeg artists for his independence and commitment.

He began his studies with Ernest Lindner and Eli Bornstein in Saskatoon, then enrolled at the University of Manitoba School of Art in 1953. His paintings during the '50s were influenced by Pierre Bonnard and Eduoard Vuillard, whose "camouflaged"[5] figures interested him, and by Max Beckmann, whose paintings he saw in Chicago. In 1958 he entered the graduate program at the University of North Dakota, encouraged by Robert Nelson who had left

5) Ivan Eyre in conversation with Christopher Varley, February 28, 1983

Ivan Eyre
Stills: Black Ducks, 1970
acrylic on canvas
157.3 x 205.7 cm.
Collection of the artist,
Winnipeg

Winnipeg to head its art department. The following year, he briefly lived in Dover, Massachusetts, then returned to Winnipeg to teach at the art school.

In 1961 he had decided to purge himself of outside influences, and began making large numbers of drawings to determine what was essentially his. The paintings that followed still owed something to Beckmann's allegorical images and biting line, but Eyre littered his crawling, twisted, haunted figures across the vast space of the plains. These symbols of alienation, suffering, and paralysis bespoke of folly and ignorance. The large acrylics that followed in the late '60s were more immediately attractive, but hardly less unsettling or mysterious.

Like FitzGerald, Eyre never counted on local interest or support. But this indifference was a rare luxury anywhere in the West, and could only be afforded by those who found secure employment or achieved success elsewhere. For artists who were not so fortunate, Winnipeg was a good city to leave.

Jack Markell
The Wedding Shawl,
c. 1955
oil on masonite
121.7 x 101.5 cm.
Collection of The Winnipeg
Art Gallery. Acquired with
funds from the Winnipeg
Tribune

Seeds on Rocky Ground
Calgary and Edmonton, 1945-1970

The three Prairie Provinces have proved themselves even less sympathetic to the original artist than the rest of the country. Talent appears here as elsewhere; but an unsympathetic environment acts as an emetic force on those who do not conform to its philistinism, or do not care to put up with its indifference.[1]

T hus, Maxwell Bates began his attack in a 1948 issue of *Highlights*, published by the Alberta Society of Artists to help inform and hold the small Alberta art community together. Nowhere was the philistinism that he referred to more oppressively felt than in that province.

As far as the rest of the world was concerned, Calgary and Edmonton were still in the cultural wilderness before 1970.[2] Vancouver and Winnipeg exuded mellow sophistication by comparison. Alberta could claim no Carrs or FitzGeralds as native sons or daughters. Its most distinguished painters were conservative Englishmen who took a dim view of the sloppy liberties of modernist art.

And yet the seeds had been planted. The Edmonton Museum of Art (now The Edmonton Art Gallery) was incorporated in 1924, and under the guidance of Maude Bowman, it programmed with some flair. In the early '30s in Calgary, A.C. Leighton ran the art department of the Provincial Institute of Technology and Art, and organized the Banff School of Fine Arts and the Alberta Society of Artists. In 1936 H.G. Glyde, another expatriate Englishman, became head of the Department of Art at the 'Tech', and of the art department in Banff. A devoted art teacher, he deplored the backwardness of Alberta, and wanted to bring other artists, writers — even theatre troupes and small orchestras — out from Britain to build the foundations for a stronger culture. But Alberta was poor, and this sort of British domination of the school system was starting to meet resistance.

When Glyde moved to Edmonton in 1946 to organize the art department at the University of Alberta, he asked Jock Macdonald, a Scotsman living in Vancouver, to replace him at the Tech. But Macdonald stayed only a year, and when he left for Toronto, he recommended Saskatchewan-born Illingworth Kerr to take his place.

1) Bates, Maxwell; "Some Problems of Environment", *Highlights*, Vol. 2, No. 8, December 1948, p. 2

2) Calgary's population was 129,060 in 1951, and Edmonton's was 159,631.

Kerr oversaw the rapid expansion and the Canadianization of the art department after the war. Like the Vancouver School of Art, the Tech grew so quickly in the early post-war years that students stayed to teach, and some real momentum was generated. Following Macdonald's example, Kerr and Marion Nicoll, a former student of Leighton's who taught design, took up 'automatic' painting. Although Kerr's experiments with this surrealist-derived technique always ended up looking like animals, Nicoll's robust watercolour doodles earned her a reputation as Alberta's first committed abstract artist. In fact, many were stronger than Macdonald's automatics, which all too often were embroidered with fussy embellishments.

Nicoll now receives the most recognition, however, for the large, flat-patterned canvases that she began painting after studying with Will Barnet at the Emma Lake workshop of 1957 and then, in his class in New York. She made distant reference to Indian hierglyphs and cityscapes in these paintings, seeking to express her feelings for universal, classical order — a far cry from her seemingly random automatics.

Kerr, who studied with J.E.H. MacDonald and other members of the Group of Seven at the Ontario College of Art in the '20s, was primarily a painter of animals and landscapes who occasionally experimented with abstraction. He admired Franz Marc, and like him, tried to visualize the relationship that animals experienced with their environment. He is much better known, however, for his

Illingworth Kerr
Oil, Drumheller, c. 1952
watercolour on paper
36.8 x 54.5 cm.
Collection of Glenbow
Museum, Calgary

J.W.G. Macdonald
No. 2 Fish and Birds,
1945
ink and watercolour on
paper
25.2 x 35.6 cm.
Collection of The Edmonton
Art Gallery. Gift of Dr.
Illingworth Kerr, 1981

Marion Nicoll
Untitled (Automatic)
1960
watercolour on paper
35 x 22.7 cm.
Collection of The Edmonton
Art Gallery. Purchased in
1982 with funds from the
Miss Bowman Endowment

boldly designed landscapes which emphasize the carpet-like patterns of the rolling Alberta farmland and massive angularity of the Rocky Mountains. His large, broadly laid-in watercolours of the '50s are especially vivid, and display to the full his gifts for colour.

In lieu of a municipal art gallery, the Calgary Allied Arts Centre also played an important role after the war, and helped to bring the various factions of the cultural community together. Douglas Morton, who was curator of the Centre from 1951 to 1953, recalls that Bob Kerr wired it for sound, and held musicales every Sunday night. The model railway club and various art classes met on other nights. And sandwiched between these other functions was an exhibition program that included both locally organized and touring shows, such as those provided by the Western Canadian Art Circuit, and other art organizations.[3]

Calgary's art community tended to divide between 'mountain painters', like Roland Gissing, and what the young-bloods called 'real painters', the most admired of whom was Maxwell Bates. Bates was something of a moral force in the city, for his honesty and dedication apparently impressed nearly everyone. Roy Kiyooka, who met him while studying at the Tech, later described him as an important model in his own life,[4] and Morton thought that he was the best painter in Alberta.[5]

3) Douglas Morton in conversation with Christopher Varley, July 28, 1981

4) Kiyooka, Roy; "Preface", *Maxwell Bates,* (exhibition catalogue) Norman Mackenzie Art Gallery, November 30, 1960-January 2, 1961

5) Douglas Morton in conversation with Christopher Varley, July 28, 1981

Marion Nicoll
Ancient Wall, 1962
oil on canvas
107.6 x 153.2 cm.
Collection of The Edmonton
Art Gallery. Gift of Beta
Sigma Phi, 1963

Maxwell Bates
October Farm, 1956
oil on canvas
61.6 x 92 cm.
Collection of The Winnipeg
Art Gallery

Bates was tough and uncompromising, yet fundamentally generous. A cynical streak constantly reappeared in his expressionistic art. Like the *Neue Sacklichkeit* realists of Weimar Germany whom he admired so much, he often took aim at the vanity, hypocrisy, and stupidity of his fellow man. This criticism was especially barbed in his studies of human relationships. In his depictions of games, seances, and visits to fortune tellers, he played credulity off against malevolent cunning.

One of Bates' most important mentors was Max Beckmann, under whom he studied at the Brooklyn Museum Art School in 1949-50. Like Bates, Beckmann was primarily a figure painter whose social comments were often expressed in allegorical terms. Bates emulated his coarse, expressionist-derived technique, frequently employing the same sorts of garish, discordant colours and heavy black brush drawing. His paintings were generally more

simply organized and easily comprehensible than Beckmann's, however, and his love of grids and ornamental patterns also related to cubism and Matisse.

Bate's importance to western Canada still appears to be poorly understood, in part because so many of his paintings were so bad or derivative. He often shows to better advantage in his landscapes and watercolours than in the figure paintings for which he is best known.

Bates was close to John Snow, who pulled his prints and shared his taste for social commentary and modern German graphic art. Although there was something indefinite about the expressionism of Snow's early prints, and he eventually turned toward purely decorative lithography (as well as highly entertaining sculpture), his early woodcuts provide fascinating insights into the

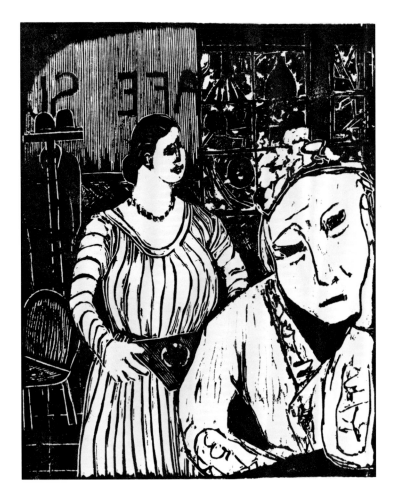

John Snow
Café, 1952
woodcut on paper
35 x 28.5 cm. (image size)
Collection of The Edmonton
Art Gallery. Purchased in
1983

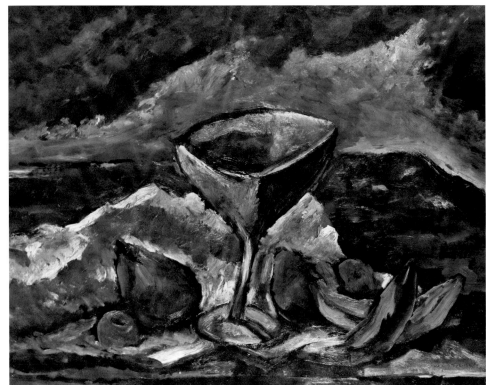

W.L. Stevenson
Untitled, n.d.
oil on board
61 x 76 cm.
Collection of Glenbow
Museum, Calgary

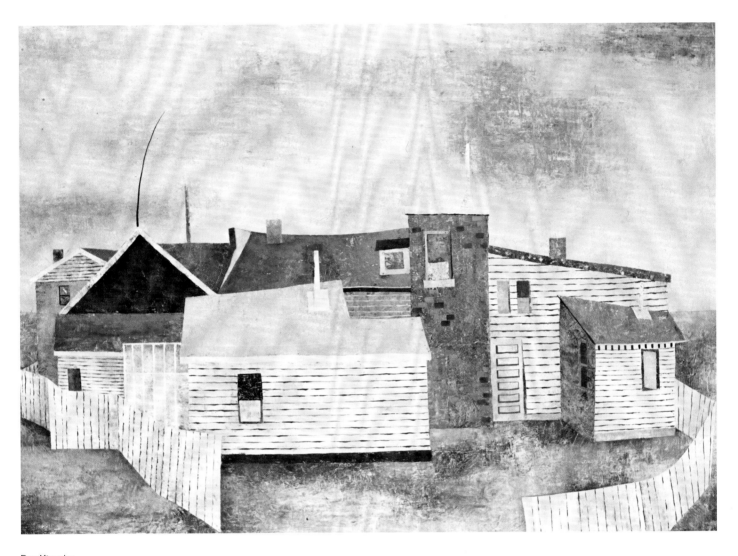

Roy Kiyooka
Pastoral, 1955
oil on board
85.1 x 119.4 cm.
Collection of Glenbow
Museum, Calgary

perception of modernism on the prairies prevalent during the '40s and '50s. Like so many other artists, he turned to German expressionism for his models and themes. It was as if they saw only the winter bleakness, not the effervescent summertime beauty of their surroundings.

This is certainly also true of W.L. Stevenson, Bates' old friend who returned to Calgary from Vancouver in 1953. Even his early Cezannesque still-lifes were filled with northern intensity and darkness. The paintings that he made after his return were as violent as Goodridge Roberts' late landscapes, with which they have often been compared.

Many among the next generation of Calgarian artists made names for themselves only after leaving the city. Douglas Morton, Roy Kiyooka, Arthur McKay, and Ted Godwin all moved to Regina. Morton recalls that while there was "a lot of group thinking and interaction" in Calgary, "there was a general feeling that we needed some tough professional input from outside."[6] The city was too small, too isolated, and with the end of the immediate post-war expansion, employment had become harder to come by.

6) ibid

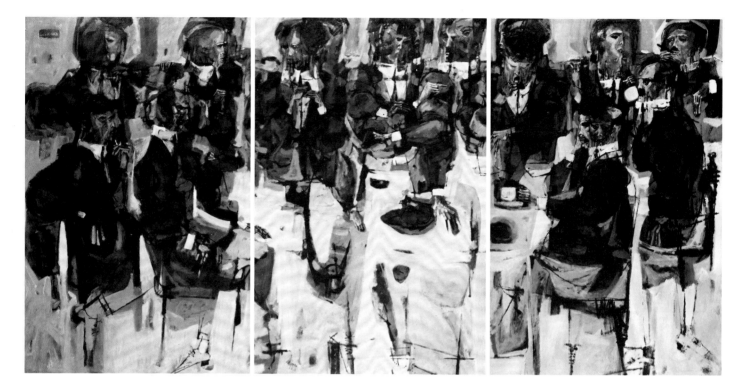

Ronald Spickett
Supper (triptych), 1964
oil on masonite
182.9 x 121.8 cm. (each
panel)
Collection of The Edmonton
Art Gallery. Gift of the West
End Rotary Club of
Edmonton

Judging from the paintings of Kiyooka and Ronald Spickett, many of this next generation were interested in the socially-conscious Mexican muralists and Rica Lebrun, the widely influential Los Angeles figure painter. Both artists studied with the American cubist James Pinto in San Miguel, Mexico, in 1956-57. Before leaving Calgary, Kiyooka made a series of planar, stylized cityscapes and farm scenes, most of which were tentative and unexpressive. But the Mexican portraits and village scenes that followed were pictorially intense and romantic.

Kiyooka moved to Regina shortly after returning to Canada, and Spickett returned to Calgary to teach at the Tech. For several years he practised calligraphic 'drip' painting based on "the subtle interplay of forms, spaces, and textures found in Prairie grass."[7] These met with considerable favour, for critics recognized the affinities to Jackson Pollock, but the dark ecclesiastical figure paintings that followed received much less attention. Spickett painted these huge religious subjects in the grand manner characteristic of Lebrun, successfully adopting his wiry contour drawing, patina, and virtuoso techniques. 'Old fashioned' as these paintings might have been, they were also impressive, and deserve to be better known.

7) Ronald Spickett to Christopher Varley, April 19, 1983

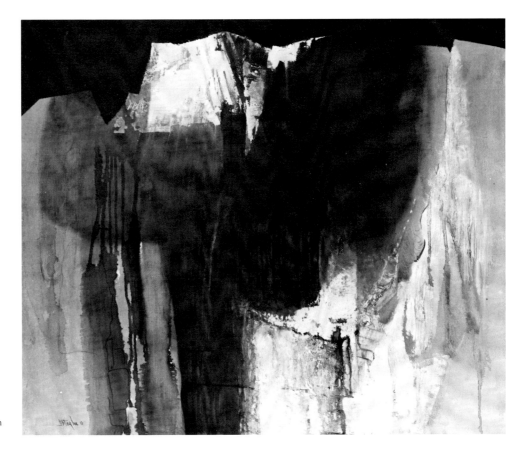

J.B. Taylor
Landscape, 1963
acrylic on board
71.1 x 86.4 cm.
Collection of The Edmonton
Art Gallery

Douglas Haynes
1 · Feb./69, 1969
mixed media on board
101.6 x 121.9 cm.
Collection of The Edmonton
Art Gallery. Purchased from
the artist.

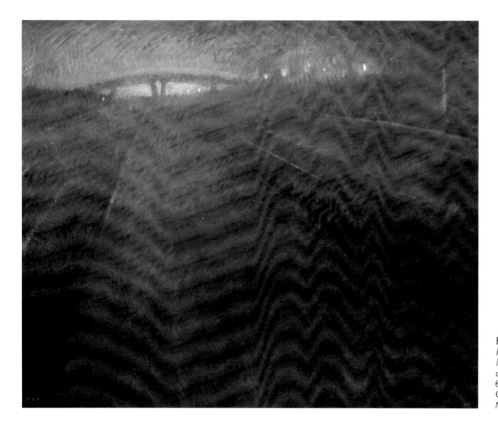

H.G. Glyde
Highway #2 Going North, 1960
oil on canvas
69.4 x 84.5 cm.
Collection of Glenbow
Museum, Calgary

If Calgary had difficulty in consolidating and building upon its post-war gains, Edmonton faced even deeper problems. It was an isolated civil service community with little to substantiate its claims of cultural superiority over 'Cowtown' to the south. It had few artists before 1960, and most of these were amateurs.

H.G. Glyde brought an element of professionalism to the city when he moved to the University of Alberta in 1946. But he had little sympathy for modernist art or the local painters, and his post-war paintings often fell within the well-worn traditions of 'Canadian scene' painting, as practised by his friend A.Y. Jackson. J.B. Taylor, who came to the University in 1947, worked in a similar, yet slicker vein.

Like Thomas Hart Benton, who he obviously admired, Glyde also painted classical allegories set in the prairies. And when he put aside the stylistic clichés of Benton and Jackson, and looked directly at his surroundings, he made some paintings of real originality and force. Similarly, Taylor sometimes got beyond the graphic commercial look of most of his paintings with his abstracted landscapes of the early '60s.

Douglas Haynes, who received his training at the Tech, was among the more determined of the second generation of post-war Edmonton artists. As Clement Greenberg noted on his first trip to the city in 1962, Haynes' etchings were "unabashedly" influenced by Adolph Gottlieb's abstract expressionist 'burst' paintings.[8] Perhaps because of his interest in this medium, Haynes was also attracted by the high relief and heavy textures of Antoni Tapies' work. His paintings of the late '60s were as much built as they were painted, and often exploited symmetrical cellular images.

Whereas Winnipeg relied too heavily on outside guidance, and ended up with teachers and artists who were unsympathetic to what had gone on before, or who would not stay, Calgary and Edmonton were unable to attract outside talent. Nor did they seem very open to it. Faced with the task of re-inventing the wheel on their own, they struggled, and got off to a slow start after the war. But the seeds that were scattered during these years germinated, and a few took root, and from them has grown the active artistic community that we know today.

8) "Clement Greenberg's View of Art on the Prairies: Painting and Sculpture in Prairie Canada", Canadian Art, Vol. XX, No. 2, March/April 1963, p. 95

The Regina Vanguard
1958-1966

Arthur McKay once told the story of an Irishman who packed his bags and prepared for a trip. He was asked by his neighbours where he was going:

He said, "I'm going to Connemara."
They said, "You mean, you're going to Connemara, God willing."
He said, "No, I'm going to Connemara."
God heard him and changed him into a frog and he lived in a frog pond for seven years. When he returned as a man again he began to pack his bags.
The people asked him where he was going and he said, "I'm going to Connemara."
They said, "You mean, you're going to Connemara, God willing."
He said, "No, I mean I'm going to Connemara or I'm going back to the frog pond."

In telling this story, McKay hoped to shed light on the "characteristically unsteady and elusive" [1] search for meaning and expression in art and life, but it could just as easily apply to Regina, that curious frog pond/spring board to national prominence which is set in the middle of the Saskatchewan plains. Small, isolated, almost cellular in shape and self-containment, it provided the setting for a remarkable flowering of abstract painting during the late '50s and early '60s. Yet, also being a frog pond, it could not sustain this growth, and the city ultimately proved to be confining. By the mid-'60s, its 'scene' had collapsed, and the most important players had left.

Institutions played an even more important role in Regina [2] than in the other cities covered in this survey. Regina College, a junior college affiliated with the University of Saskatchewan since 1934, provided the art gallery and school around which artists gathered. In 1950, 24-year-old Kenneth Lochhead was appointed principal of the College's art school. Two years later, Arthur McKay joined him on staff, and plans were drawn for an art gallery and studio facilities. The nucleus of a collection and funding for the building came from the estate of Norman Mackenzie, after whom the new art gallery was named. Richard Simmins, curator of the

1) *Statements: 18 Canadian Artists, 1967* (exhibition catalogue), Norman Mackenzie Art Gallery, Regina, November 16-December 17, 1967, p. 66

2) Regina's population was 71,319 in 1951, and 112,141 in 1961.

Arthur McKay
Untitled, 1957
watercolour on paper
58.4 x 44.2 cm.
Collection of The Edmonton
Art Gallery. Donated by Fil
Fraser, 1982

Mackenzie collection since 1951, became the first director of the gallery when it opened in 1953. In 1957 a further extension was added to the building.

The modern Emma Lake workshops emerged next. Held on property north of Prince Albert that Augustus Kenderdine donated to the University of Saskatchewan, they were run during the '30s and '40s by Kenderdine, who taught landscape painting, and by Dr. Gordon Snelgrove, who taught art history. Saskatoon artists Reta Cowley, Mac Hone, Dorothy Knowles, and Otto Rogers were among those who attended. It remained a modest summer art camp until 1955, however, when Lochhead persuaded the University of Saskatchewan to turn it over to Regina College to be led by professional artists from outside of the province. As Lochhead later recounted:

> *The idea of this project arose as a partial answer to the problem of isolation... When Art McKay and I discussed this whole thing at the very beginning, it was a matter of: Wouldn't it be nice if we could get some people to come* here, *and then it would help us personally. It arose out of a very personal need as well as a need which we felt other artists and painters on the prairies would also have... If we can't get out, then let's bring someone from the outside to us.*[3]

Lochhead and McKay turned to Vancouver for their first workshop leaders. Jack Shadbolt attended in 1955, and, partly on his recommendation, Joseph Plaskett led the group in 1956. Artists from Regina and Saskatoon enrolled for these first sessions.

In 1957, largely on the recommendations of Shadbolt and George Swinton, Lochhead invited New York painter and teacher Will Barnet to Emma Lake. The workshop has been led by American or English artists ever since. And it was at this time that its influence began to grow beyond Saskatchewan. Lochhead recalls that many Calgary painters attended Barnet's session.[4] These included Marion Nicoll, who, as we have seen, was so impressed with Barnet that she later studied with him in New York, and adopted his flat patterned style of design.

With Lochhead away on sabbatical, a workshop was not organized for the summer of 1958. But during his absence, major changes took place at the College and at Emma Lake. Roy Kiyooka, from Calgary, took over his classes. Young and brash, Kiyooka wanted nothing more than to get something going — to address the 'big issues.'

But the catalyst that jolted the College to life was Ronald Bloore, Richard Simmins' replacement as director of the newly expanded Norman Mackenzie Art Gallery in 1958. Ambitious, enthusiastic, and knowledgeable, he quickly became "known as one of Canada's most brilliant, if somewhat unorthodox young directors." [5]

3) King, John; *A Documented Study of the Artists' Workshop at Emma Lake, Saskatchewan of the School of Art, University of Saskatchewan, Regina, from 1955 to 1970,* B.F.A. thesis, University of Manitoba, 1971, p. 2

4) Kenneth Lochhead in conversation with Christopher Varley, December 12, 1981.

5) Simmins, Richard B.; "R.L. Bloore" *Canadian Art,* Vol. XIX, No. 2, March-April, 1962, p. 114

Ronald Bloore
Painting, 1961
oil on masonite
122 x 198 cm.
Collection of The Edmonton
Art Gallery

Arthur McKay
The Void, 1961
stovepipe enamel and flat
white on masonite
121.3 x 121.7 cm.
Collection of The Edmonton
Art Gallery. Purchased in
1981 with funds donated by
PCL Construction Ltd. and
matched by The Edmonton
Art Gallery Acquisition Fund

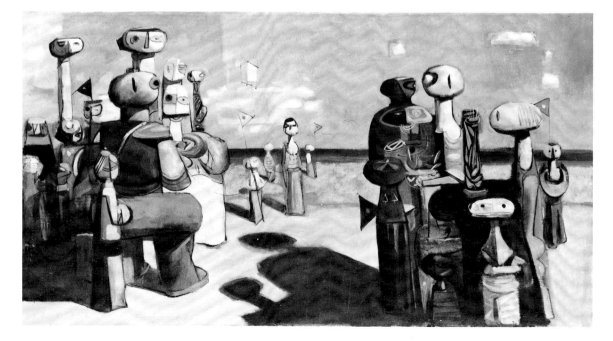

Kenneth Lochhead
The Dignitary, 1953
oil on canvas
41.2 x 76.5 cm.
Collection of The National
Gallery of Canada

Ronald Bloore
Le Foret Mecanique,
1958
stove pipe enamel on
masonite
114.3 x 206.4 cm.
On loan to the Moose Jaw
Art Museum and National
Exhibition Centre. Property
of the Government of
Saskatchewan

Ronald Bloore
*Mandala,*1960
oil on masonite
56.5 x 56.5 cm.
Collection of Dorothy X.
Bloore, Toronto

Among the first exhibitions that he booked were *Painters Eleven*, organized by Exhibition and Extension Services, which was then headed by Simmins, at The National Gallery, and *Jacques Lipchitz,* organized by the Winnipeg Art Gallery. In February 1960, Bloore organized a *Purchase Award Exhibition* that included several works each by Guido Molinari, Derek May, Anne Kahane, Graham Coughtry, Kazuo Makamura, Aba Bayefsky, Jack Shadbolt, and Gordon Smith, and from which a fine Molinari was acquired. Late the same year, the *Abstract Artists' Association of Montreal* was also exhibited,[6] its stop in Regina part of a tour arranged for the Western Canadian Art Circuit.

Bloore also championed the folk realism of retired Saskatchewan farmer Jan Wyers, and is remembered by his art history students for his introduction to them of Willem de Kooning, Franz Kline, Jackson Pollock, and other American abstract expressionists. In short, he acted as an important conduit between Regina and the outside world.

6) Presumably the *Non-Figurative Artists Association of Montreal.*

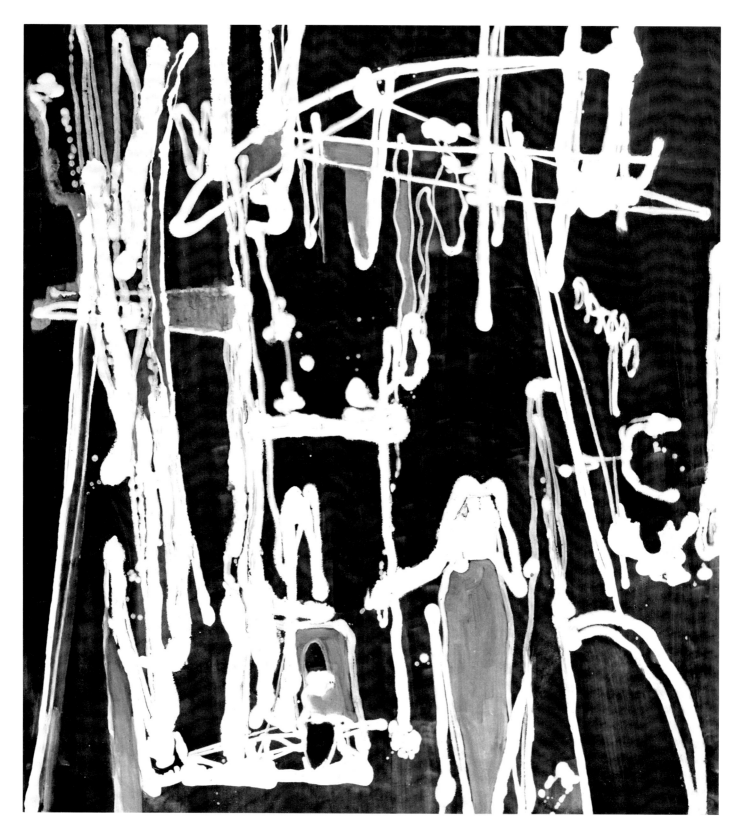

Douglas Morton
Green Night, 1961
oil on board
129.6 x 139.7 cm.
Collection of the artist,
Victoria

Roy Kiyooka
Untitled, 1960
oil on masonite
152.5 x 183 cm.
Collection of the Canada
Council Art Bank, Ottawa

Kenneth Lochhead
Victory, 1961
gesso and tempera on
pressed board
122 x 91.5 cm.
Collection of the Agnes
Etherington Art Centre,
Queen's University,
Kingston. Gift of Ayala and
Samuel Zacks, 1962
(not included in the exhibition)

But Bloore was also an ambitious and influential painter. Whereas Lochhead does not seem to have made much of a mark with his quasi-surrealist social realism of the '50s, and McKay apparently kept to himself, Bloore encouraged others to follow his lead. His cellular enamel-on-masonite paintings of the period marked a radical departure from the nature derived abstraction of most other Canadian painters. McKay and Kiyooka — especially Kiyooka — came under their influence. Kiyooka's *Emma Lake* watercolours of 1959, and white *Hoarfrost* paintings of 1960, appear to have grown directly out of Bloore's art.

Another major event that occurred in Lochhead's absence was the 1959 Emma Lake workshop. Responsibility for picking the leader fell on Bloore, Kiyooka, and McKay, who flipped through art magazines, searching for painters who looked interesting.

They finally picked Barnet Newman's name out of a hat. Although they apparently did not know it at the time, he was a major figure among first generation abstract expressionists, and formed one of the bridges to later 'colour field' painting. His attendance helped confirm Bloore's direction and authority, and encouraged McKay to move towards greater gestural abstraction. But the workshop also drew two other Regina painters closer to the fledgling group that was emerging at the College.

These were Douglas Morton, who left the Calgary Allied Arts Centre in 1953 to start a branch of his family's business in Regina, and Ted Godwin, who was transferred to Regina in 1958 when the neon company that employed him closed its office in Lethbridge. Although they are generally regarded as secondary figures within the group, they were just as affected as the others by Newman's character and ideals, and they returned to Regina with renewed energy and ambition.

The upshot of these events was Bloore's decision to organize a group exhibition at the time of the Canadian Museums Association's (C.M.A.) annual convention in Regina in 1961. It included recent drawings and paintings by Bloore, Godwin, Lochhead, McKay, and Morton, as well as examples of the work of the architect and art collector, Clifford Wiens. Roy Kiyooka, who had moved on to the Vancouver School of Art the summer before, was not included.

Among the C.M.A. delegates was Richard Simmins. He was amazed to see that so much had happened since he had moved to Ottawa, and decided to bring the five painters together again in an exhibition at The National Gallery that was to later tour the country. For the sake of convenience, Wiens and Kiyooka were not included, although both were close to the other artists. *Five Painters from Regina* was, therefore, as much the result of compromise as of friendships and common purpose.

The catalogue that Simmins prepared for the exhibition is largely responsible for the subsequent identification of the so-called[7] Regina Five as a closed and cohesive group. Charles Comfort, Director of The National Gallery, set the tone in the foreword. Like an explorer in search of exotica, he declared, "the Gallery has deliberately sought out new artists' associations or 'schools'."[8] But in Simmins' introduction it soon became clear that the Gallery was not simply acting as a disinterested observer. Simmins assumed the role of self-proclaimed spokesman and critic, frowning at some practices and smiling approvingly at others. Bloore was "a great plastic innovator", but Godwin was the "least sophisticated member of the group." Lochhead, who Simmins presumably knew best, was the most sympathetically treated.

It was in his attempts to speak *for* the artists, and to interpret their practices, however, that Simmins imposed his views most forcefully:

> A painting is the bringing into being of an emotional experience — crystallized into a significant plastic form. Feeling and intuition are supreme. Permanence is to be found only within individual experience. The standard is the individual personality. A work of art — any work — has importance only in relationship to the individual who creates and the individual who perceives. Art has little to do with the intellect. You cannot dissect it like a biological specimen nor can you really analyse it verbally. Excessive talk brings with it death. Logic has no place in the world of art, in fact art is the antithesis of logical, foreseeable development. What is the world? My understanding is the world and it has little or no independent existence outside of myself. What of permanence again? An understanding in depth of the unique personality.[9]

And so it went. It is no wonder there has since been so much talk of 'Prairie Zen' and McKay's LSD experiences. What room did such rhetoric leave for the mundane interchanges — the drinking and the squabbling — through which the 'group' actually developed?

And what about the paintings? While Simmins pronounced strong judgement on them, he was not clear about what made them good or bad. How did they 'measure up' against art in other Canadian cities? What made them distinctive?

The most salient characteristics of these five painters were their commitment to abstraction and their receptiveness to contemporary American art. They tended to work on a larger scale than their contemporaries in Vancouver, and, as Simmins attempted to illustrate, found meaning in the act of painting rather than in abstracting from nature.

At 36, Bloore was the oldest and most mature of the five. In his statement for the 'Five Painters' catalogue, he expressed the hope of "making a preconceived image function formally as a painting". There was little room for spontaneity in his severe and reticent art. His images were simple — grids, emblematic mandalas, and symmetrically balanced stars or bars — and his palette was usually limited to various whites, with the pigment scraped into patterns or ridges that gave his paint surfaces a tactile, almost subliminally sensuous quality.

McKay adopted Bloore's mandalas and also painted on masonite. But whereas Bloore's paintings were austere and restrained, McKay's were palpable, living things:

> The onlooker's senses, like the artist's, dilate in awareness of fathomless outer space, of inner psychic depths. Fine flecks of living sable black, translucent with golden sienna, swirl slowly into the vortex of Inward; grey Microcosm shimmers with the bloom of a pigeon's wing; a curdled, cracked and pitted planet is pierced by a violent red-black thrust in Image of Potential; Effulgent Image has the mesmeric magnificence of some far-off sun a billion years in age. "First feel, think afterwards," says McKay, to himself and to viewers of his work. The literal finger exploding the surface of Effulgent Image feels, amazed, the kid-glove smoothness of juicy enamel scraped over masonite board — the pleated crumpling and mottled embossing of the radiant disk is surrealist illusion; light gleams back from below the thinnest glaze while the opaque perimeter plunges into blackest night.[10]

Godwin was the youngest of the five, and by far the most hedonistic in his use of colour. By working on canvas he was able to expand beyond the 4' x 8' limitations of masonite sheets, and he produced some of the largest paintings in The National Gallery's exhibition. He initially relied on the "organic accidents" that occurred when he spontaneously brushed on large areas of bright colour. Then he adjusted and refined the images until satisfied with the results. These looked something like Jock Macdonald's paintings of the late '50s, but, if anything, they were fresher and more spontaneous.

The problems were that they tended to look arbitrarily cropped, or seemed to burst out of the picture plane (whereas Bloore's paintings sometimes looked cramped within it). And 'freshness' was not yet the order of the day. In an outburst of prescriptive criticism, Simmins later wagged his finger at Godwin:

> ...art should not please; anything hedonistic is to be distrusted. The artist should always be a Jacob wrestling with an angel; sweating and struggling, yearning infinitely towards an understanding of the cosmos.[11]

But Godwin did not learn, and his 'tartan' grid paintings of the late '60s were unabashedly sensuous and pleasing.

Having abandoned his quasi-surrealist paintings of the '50s, and fallen behind the others during his sabbatical, Lochhead was attempting to catch up at the time of The National Gallery exhibition. Unfortunately, his innate gifts as a stylist often worked against him, and his semi-figurative Franz Kline derived calligraphy of 1960-61 has not stood up well over the years. The painterly licks

7) Kenneth Lochhead in conversation with Christopher Varley, December 12, 1981.

8) Comfort, Charles F.; "Foreword", *Five Painters from Regina* (exhibition catalogue), The National Gallery of Canada, 1961

9) Simmins, Richard B.; "Introduction", *Five Painters from Regina* (exhibition catalogue), The National Gallery of Canada, 1961

10) Jackson Groves, Naomi; "Five Painters from Regina at the National Gallery of Canada, Ottawa", *Canadian Art*, Vo. XIX, No. 2, March-April 1962, p. 101

11) Simmins, Richard B.; "Ted Godwin", *Canadian Art*, Vol. XIX, No. 2, March-April 1962, p. 125

Ted Godwin
Red Grew, 1961
oil on canvas
169 x 199.5 cm.
Collection of Glenbow
Museum, Calgary
(not included in the exhibition)

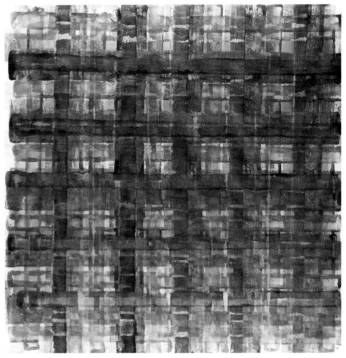

Ted Godwin
Tartan for Phyllis No. 2,
1969
oil and lucite on canvas
294.6 x 294.6 cm.
Collection of Glenbow
Museum, Calgary

and scumbling of these oils was just a little too slick and breezy. It was not until about the time of the Clement Greenberg workshop in 1962 that he finally succeeded in marrying style with expression.

Morton displayed as much facility as Lochhead, but in pouring his paint and adding disparate bits of collage, he achieved greater rawness and impact. To some paintings, he added flat patches of colour in the areas between the tracery of poured paint. Subsequently, he gradually moved towards geometric abstraction in which these patches expanded and the dripped lines became 'hard edge' contours.

The painters of Regina Five were never as cohesive a lot as the Group of Seven or the Automatistes. They did not write or frequently exhibit together. Nor did they all feel comfortable about their communal fate. Indeed, tensions existed between them from the time that Bloore arrived and challenged the others to raise their sights. He was a natural leader, but like many leaders, somewhat dogmatic. As the other painters grew in strength they began to challenge his authority and views. Rifts developed. Bloore became defensive. He criticized McKay for painting mandalas, as if the mandala had been his own invention. Lochhead reputedly avoided him in the halls.[12] But in a city as small as Regina there was no escape, and personalities became a major issue.

The events that ultimately split the art community, however, resulted from a decision to take Barnet Newman's advice and invite the American critic Clement Greenberg to the Emma Lake workshop of 1962.[13] Greenberg was nearing the height of his influence at the time, and was championing the paintings of Clyfford Still, Mark Rothko, and Newman. He was a persuasive writer who viewed modernism as a dialectical process through which painting moved towards greater 'purity', by gradually elimi-

nating 'extraneous' elements derived from other art forms. This sequence of events had begun with Manet's rejection of the moralizing narratives of the French Academy, and had continued through the rejection of representation itself in favour of 'autonomous' abstract art.

But Greenberg went further than this, and by 1962 was calling for an alternative to what he characterized as the "homeless representation" of Willem de Kooning and his followers. He considered their paintings mannered and boxed-in, and thought that they did not allow colour its full voice or independence:

> Unequal densities of paint become...so many differences of light and dark, and these deprive color of both its purity and fullness. And though openness is supposed to be another quintessentially painterly aim, the slap-dash application of paint ends by crowding the picture surface into a compact jumble —a jumble that, as we see it in de Kooning and his followers, is another version of academically Cubist compactness. Still, Newman and Rothko turn away from the painterliness of Abstract Expressionism as though to save the objects of painterliness — colour and openness — from painterliness itself.

12) Ted Godwin in conversation with Christopher Varley, June 4, 1983

13) The decision to invite Clement Greenberg to Emma Lake was not made by Lochhead alone. In an undated letter of early 1962 to Barnet Newman, Kenneth Lochhead wrote that, "Ron and Art have suggested that I act on an idea of yours, that of inviting someone like Greenberg, or a similar critic of standing..." (quoted in King; *A Documented Study,* p. 9).

Kenneth Lochhead
Dark Green Centre, 1963
acrylic on canvas
208.3 x 203.2 cm.
Collection of the Art Gallery
of Ontario. Gift from the
McLean Foundation, 1965

Later he added:

> The ultimate effect achieved in the art of all three of these
> painters has to be described as one of more than chromatic
> intensity. It is rather an effect of almost literal openness that
> embraces and absorbs color in the act of being created by it.
> Openness — and not only in pictorial art — is the quality that
> seems most to exhilarate the attuned eye of this time.[14]

Such broad generalizations and the force with which Green-
berg expressed his opinions, met with outrage and ridicule in some
quarters, but fired ambition in others. Lochhead and many of the
painters of Saskatoon listened closely to his arguments, and were
convinced by his views. McKay later responded to the criticism of
others with 'an appreciation' that was published in *Canadian Art*:

> ...controversy has arisen following the Greenberg workshop and
> his subsequent tour (of the prairie provinces for Canadian Art). It
> seems that western Canadians, other than the workshop partic-
> ipants, prefer their critics either not to write at all or merely to
> have Canadian Civil Service appointments, or both...most of us
> are terrified that someone may tamper with our image. Cur-
> iously enough, we accept political coercion, economic domina-
> tion, Coca-Cola and predigested mass communication, while
> we resist exposure to the more humane and civilized arts from
> the U.S.A.

A paragraph later he continued:

> We have not been permitted to enjoy at home, in the original, the
> challenges thrown up by the U.S. "post war experience" in art.
> We have been fed on a tax-supported diet of English conserva-
> tism, late and little. The trade magazines which we avidly
> import have carried counterfeit aesthetic experiences containing
> the latest virus of fashion, out of scale and context. This diet is
> disastrous for anyone and especially for students. There is no
> substitute for original art.[15]

Echoing this sentiment, Lochhead took Greenberg's advice,
and invited Kenneth Noland and Jules Olitski to lead the next two
workshops; and in September 1962, with Bloore in Europe on
sabbatical and Gerald Finley replacing him as Acting Director and
Lochhead providing advice, the Norman MacKenzie Art Gallery
received permission from the Dean of Regina College to invite
Greenberg to organize two contemporary exhibitions.[16]

The first of these, *Three New American Painters: Louis,
Noland, Olitski*, opened in January 1963. Finley promoted the
exhibition with gushing enthusiasm. He emphasized Greenberg's
involvement against Greenberg's own wishes, and before it had
opened, asked for his help with other projects, including the pur-
chase of a David Smith sculpture for the Gallery grounds.[17] By the
time Bloore returned from sabbatical, Finley and Lochhead had
involved the American critic in a major part of the exhibition
program.

This shocked and enraged Bloore. He immediately wrote to
Greenberg and Joseph Hirshhorn, demanding revision or cancel-
lation of an exhibition of the Hirshhorn collection that was sched-
uled to open in less than two months. His remarks offended
Greenberg, who immediately returned the advance that he had
been given for a Hans Hofmann exhibition the following spring.
Bloore apologized, but the damage had been done. The gap
between Bloore and Lochhead, Greenberg's principal admirer in
Regina, widened. Lochhead chose to move on to the University of
Manitoba School of Art in Winnipeg less than a year later. Bloore
left Regina in 1966.

Of the five Regina artists, Lochhead was the one who benefitted
most from Greenberg's advice and encouragement. His flat
enamel paintings of 1962 were among the clearest responses to
Greenberg's call for 'openness', and his stain paintings of the
following year grew directly out of the Louis, Noland, and Olitski
exhibition. He organized large areas of bright colour into simple
images set on, or rather *into*, raw canvas grounds. With these
paintings, Lochhead finally found an outlet for his decorative gifts
that was not inappropriate or overly mannered. In recognition,
Greenberg included him in the *Post-Painterly Abstraction* exhibi-
tion that he assembled for the Los Angeles County Museum of Art
in 1964. McKay and Jack Bush were the only other Canadians
represented.

14) Greenberg, Clement; "After Abstract Expressionism", *Art International*, Vol.
VI, No. 8, October 1962

15) McKay, Arthur; "Emma Lake Artists' Workshops: An Appreciation", *Cana-
dian Art*, Vol. XXI, No. 5, September-October 1964, p. 280

16) Memorandum from Gerald E. Finley to Kenneth C. Lochhead, September
12, 1962

17) All of this and the following correspondence between Bloore and Greenberg
can be found in the Norman Mackenzie Art Gallery's files.

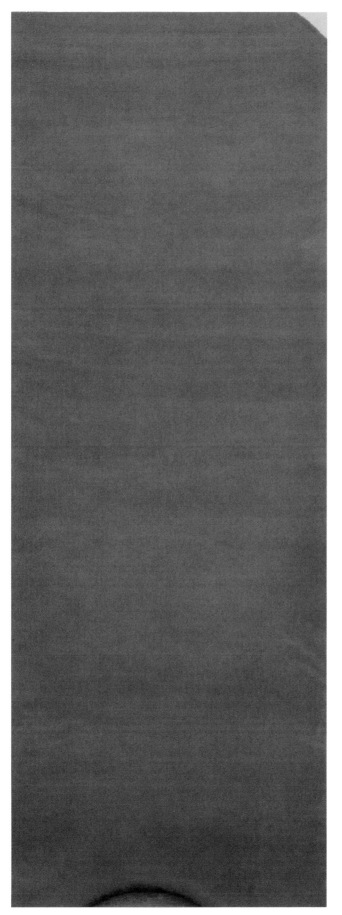

Kenneth Peters
*August Heat on a Warm
Day*, 1964
acrylic emulsion on canvas
228.5 x 84.1 cm.
Collection of The Edmonton
Art Gallery

Bruce Parsons
Aroma Red, c. 1965
acrylic on canvas
86.3 x 203.1 cm.
Collection of the
Saskatchewan Arts Board

Other Regina painters also responded to *Three New American Painters*, and to the Greenberg, Noland, and Olitski workshops. Among these was Kenneth Peters, who made some of the most radically simplified 'colour field' paintings of the early '60s, but whose production was erratic and generally derivitive, and tended to be overshadowed by the five older artists. Another was Bruce Parsons, who floated cheerfully idiosyncratic shapes across the 'fields' of his stain paintings. But like Peters, he eventually left Regina, for he too was overshadowed by the phantom of Regina Five. Later he dismissed 'colour field' painting as an adolescent indulgence, and now has trouble understanding why so many other prairie artists have so doggedly stuck with it.[18]

To explain this, we should look at both Canadian society and at the delicate beauty and openness of the prairies themselves. Aesthetically, 'colour field' painting would seem to be almost the perfect response to the prairie environment. But the devotion that Clement Greenberg, its principal advocate, still commands in some circles appears to stem as much from the deference that Canadians generally feel toward established authority.[19] Greenberg had very clear ideas about what constituted 'serious' modernist art. He ironed out the complexities of modernism, and presented it to Saskatchewan in a form that was almost mythically simple and ready for assimilation. The unfortunate side effect was that while he inspired much fine painting, his most devoted followers have tended to canonize him, treating him as the one critic who is above criticism.

But to return to McKay's story of the travelling Irishman, Regina's painters may have kept falling back into the frog pond because they tried too hard to get out of it. They were pushed into the limelight too violently too soon. And in their own impatience to cast off their provincial status they were hard on themselves and each other. Personal differences became major problems. With little relief from one another, and never enough exposure to other contemporary art, they were unable to retain their balance and perspectives.

18) Bruce Parsons in conversation with Christopher Varley, September 19, 1982

19) See Friedenberg, Edgar Z.; *Deference to Authority: The Case of Canada,* M.E. Sharpe, Inc., White Plains, New York (1980).

Self-Help in Saskatoon

1945-1970

S askatoon[1] presents a refreshing contrast to Regina and most of the other cities in this survey. Whereas Regina collapsed under the weight of personal conflicts, ideological strife, and unreasonable expectations, the Saskatoon art community came very close to the C.C.F. (Co-operative Commonwealth Federation) ideals of self-help and co-operation. Its members were as serious as any in the West, but tended to be more modest in their claims and tolerant of others. Most of them still live in the city. There has been no reason to leave.

Ernest Lindner deserves much of the credit for initially bringing this community together. Through his classes at the Saskatoon Technical Collegiate, where he began teaching art in 1936, he provided sound guidance and encouragement to his students, who included Robert Murray, Ivan Eyre, Claude Breeze, and other now familiar names in Canadian art. And through the soirées that he held most Saturdays in his home until the mid-'60s, young and old artists alike met to exchange ideas. Although Lindner was "very much in charge" of these sessions, and often "at loggerheads" with the art department of the University of Saskatchewan[2], his insatiable curiosity and energy made him an excellent catalyst for the others.

Lindner's naturalistic watercolours and woodcuts of the '40s were often awkward or painstakingly rendered, yet many included passages of real insight and beauty. He showed an early rapport with the cycles of growth and decay in the northern Saskatchewan forest, and the colour and paint handling of his large watercolours often sparkled.

Regeneration had become the major theme of Lindner's art by the '60s. He concentrated his attention on the corners of the forest, observing the growth of fungus or moss on the trunks of dead trees. The most vivid of these large watercolours were strongly composed and painted, yet rose above the limitations of a set style. Their simple truthfulness is very effective.

Saskatoon did not have a public art gallery until 1964. It did, however, have the Saskatoon Art Centre, organized along much the same lines as the Calgary Allied Arts Centre in 1944, and

1) Saskatoon's population was 53,268 in 1951, and 95,526 in 1961, making it the smallest city of the six considered in this exhibition.

2) Otto Rogers in conversation with Christopher Varley, February 27, 1983

Opposite page:

Ernest, Lindner
Decay and Growth,
1964
watercolour on paper
74.9 x 54.6 cm.
Collection of the Norman
MacKenzie Art Gallery,
University of Regina

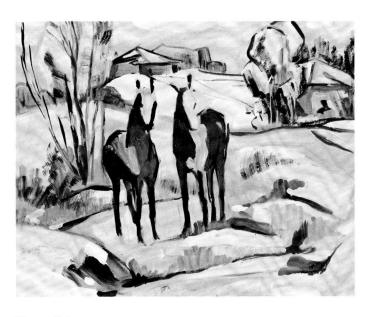

Wynona Mulcaster
The Yearlings, c. 1950
tempera on paper
63.5 x 76.1 cm.
Collection of the
Saskatchewan Arts Board

Ernest, Lindner
Bodil at Lindner Point,
1943
watercolour on paper
56.2 x 38.8 cm. (image size)
Collection of the Mendel Art
Gallery, Saskatoon

incorporating the Saskatoon Art Association, Saskatoon Camera Club, and Saskatoon Archaeological Society. Fred Mendel, a European emigré whose art collection included a great deal of modern German art, was the Art Association's honourary president. Over the next twenty years he played an important role in the community, bringing artists and collectors together, inviting European artists to Saskatoon, and, in the early '60s, providing the seed money to begin construction of the Mendel Art Gallery. Many Saskatoon artists received their first direct and continuous exposure to modern art through his collection, which helps to explain their taste for expressionism during the '50s. Many of William Perehudoff's and Dorothy Knowles' early paintings clearly derived from Edvard Munch.

The Saskatoon Art Centre was run by local volunteers until 1947, when George Swinton was hired as curator. He was an Austrian emigré, who took his art training at the school affiliated with the Art Association of Montreal (now the Montreal Museum of Fine Arts). Some of the paintings that he created during his two years of residence in Saskatoon were indebted to Fritz Brandtner's eclectic cubo-expressionist abstraction, but Swinton painted with the directness of Arthur Lismer, dragging pigment on with a palette knife or incising it with the end of his brush. At the Art Centre, "he really had things effervescing", and was the first to bring Perehudoff to public notice.[3]

3) Reta Cowley in conversation with Christopher Varley, February 26, 1983

George Swinton
Untitled, c. 1948
oil on masonite
30.4 x 40.7 cm.
Collection of the Mendel Art
Gallery, Saskatoon

Otto Rogers
Migration No. 2, 1958
oil on masonite
121.9 x 121.9 cm.
Collection of the
Saskatchewan Arts Board

Dorothy Knowles
*Landscape South of
Saskatoon,* 1963
oil on canvas
59.7 x 74.9 cm.
Collection of Dr. & Mrs. M.J.
Miller, Calgary

Wynona Mulcaster was another active member of this close knit and co-operative art community. She learned to paint largely under Lindner's guidance, and from the time of her appointment as art instructor at the Saskatoon Teachers College in 1945, she provided great encouragement and support to her talented students. Among these was Otto Rogers, who left his parents' farm in 1952 to take teacher training, and ended up in her compulsory art class. Mulcaster immediately recognized his gifts, and talked Rogers' parents into sending him to the University of Wisconsin in Madison for additional training as an art educator. He ended up spending six years in The United States.[4]

Mulcaster's other great interest was horses, which she owned, rode, and depicted in most of her early paintings. They lent an Arcadian element to her pastural landscapes. Although she knew of Franz Marc through Mendel's collection, and adopted the abrupt divisions and broken brushwork of expressionism, these paintings are much closer in spirit to the romantic idealism of Paul Gauguin.

A second artist/teacher of considerable importance was Eli Bornstein, an American graduate of the University of Wisconsin who was hired by the University of Saskatchewan in 1950. His early prints and watercolours were influenced by John Marin and Lyonel Feininger, both of whom interpreted the frenetic pace and monumental scale of modern cities with towering, teetering, and jaggedly angular forms. Reta Cowley and others looked to the same sources at this time, and Cowley's "broken glass"[5] palette knife paintings of the early '50s and her later screenprints bear some resemblance to Bornstein's work. But whereas Cowley was sensitive to the particular qualities of prairie light, Bornstein looked for the underlying relationships of light, space, and form. Irritated by the finality of these relationships in paintings, he began building painted wooden 'constructed reliefs' in the late '50s. These substituted real space for illusionistic pictorial space, permitting the shifting passage of light and shade and the movements of the viewer to alter the formal relationships within each work.

Bornstein has acted as a virtual lone advocate of 'structurism' in Canada since the late '50s, finding much of his companionship in Chicago, which was the home of the Bauhaus after it was closed in Germany. Under the aegis of the University of Saskatchewan, he has published *The Structurist,* annually from 1960 to 1972, and biennially since then. It is an unusual example of the length of time that positions can be maintained with little more than institutional support within an artist's own community.

Saskatoon artists were the most eager participants in the Emma Lake workshops of the '30s, and were among those who benefitted most from the Clement Greenberg, Kenneth Noland, and Jules Olitski workshops of the early '60s. These created none of the type of controversy that split Regina. Most of the artists were simply grateful to receive outside attention.

Greenberg was particularly helpful to Dorothy Knowles, for he recognized her gifts as a landscape painter, and encouraged her to develop these rather than to struggle with abstraction. During the next few years she blossomed — expanding her scale and laying down transparent washes over loose charcoal drawings. The best of these delicately tinted paintings spontaneously capture the ephemeral beauty of the prairies.

Eli Bornstein
Downtown Bridge #4,
1954
colour etching and
screenprint on paper
26.4 x 29.4 cm. (image size)
Collection of the Mendel Art
Gallery, Saskatoon

Eli Bornstein
*Structurist Relief No. 18-
1 (model),* 1958-59
painted wood
22 x 29.5 x 3.8 cm.
Collection of the artist,
Saskatoon

4) Otto Rogers in conversation with Christopher Varley, February 27, 1983

5) Cowley's term

Reta Cowley
*Potash Plant and Wolf
Willows,* 1968
watercolour on paper
55.9 x 76.2 cm.
Collection of the Norman
MacKenzie Art Gallery,
University of Regina. Gift of
the Art Gallery Society, 1969

Otto Rogers
Flight of Birds, 1967
welded steel
116.9 cm. high
Collection of the artist,
Saskatoon

Reta Cowley's development parallelled that of Knowles. She too struggled with abstraction, but was most naturally responsive to prairie light and landscape. In the early '60s, she moved towards an immediate response to it. While her impressionistic watercolours tended to be repetitive, they are highly appealing, for they float like untroubled clouds across the paper.

Henri Bonli, William Perehudoff, and Otto Rogers were Saskatoon's most adventurous abstract painters of the '60s. Like Rogers, Bonli was given early encouragement by Mulcaster. He moved from gestural, nature derived abstraction in the early '60s to 'hard edge' abstraction later in the decade. Beneath the intense chroma of his later paintings, he continued to make references to the flat, open prairie landscape.

Perehudoff also employed high key colour, but to entirely non-objective ends. He butted simple shapes up against one another, often spreading them like splayed open boxes across the unprimed canvas 'fields' of his paintings. His later paintings, with their sun-like discs and atmospherically painted grounds, alluded to nature once again.

Rogers was never tempted by the delights of bright, brassy colour, and he alluded to nature in nearly all of his paintings and sculptures. Even before returning to Saskatoon from the University of Wisconsin, he produced work of considerable maturity, including the first of his large Klee-derived 'crowd' paintings, and some welded steel sculpture. He learned very quickly, and was remarkably gifted at handling materials. His constructed sculptures of the mid-'60s were among the first in Canada to make intelligent use of David Smith's inventions, including disjunction. But Rogers looked to early 20th Century European art — especially to cubism — for most of his ideas. And his art is imbued with his own style and character. Even his 'tree' paintings of the mid '60s, which were inspired by the simple power of Kenneth Noland's 'targets', have a mellow ambience that was completely his own.

Otto Rogers
Sunset Stillness, 1966
oil on primed cotton canvas
152.4 x 152.4 cm.
Collection of the Mendel Art
Gallery, Saskatoon

Dorothy Knowles
Sturgeon Lake, 1971
charcoal with oil and
turpentine wash on canvas
76.9 x 77.2 cm.
Collection of the Mendel Art
Gallery, Saskatoon

William Perehudoff
Nanoi No. 12, 1969
acrylic on canvas
172.5 x 192.5 cm.
Collection of the Canada
Council Art Bank, Ottawa

At the risk of leaving the impression that post-war Saskatoon was an artist's utopia, it should be stated that it was the one community in this survey that seems to have kept desires, delusions, and personal differences in check without impinging on anyone's personal freedom. With few institutional jobs available, entrenched coalitions did not develop, and the artists were so closely involved with the Saskatoon Art Centre that it remained closely involved with them. Almost predictably, the professionally run Mendel Art Gallery that replaced it had much less to do with most of the artists for its first fifteen years.

And yet this does not seem to have done any real damage. This suggests that while institutional support may provide an alternative to public indifference, it is not necessarily necessary. In a country like Canada, where everything is done by committee, and administrators and boards often have more power to shape culture than artists, it is reassuring to find a community like Saskatoon, where artists helped each other to help themselves.

Henri Bonli
Untitled (Ocean #2)
gouache on buff paper
45.5 x 61.9 cm.
Collection of the Mendel Art
Gallery, Saskatoon
(Exhibited in Edmonton
only)

Vancouver in the Sixties:
Bright with Promise

L ife in British Columbia is wonderful — or so claimed the tourist industry's slogans. And in the free love, fast food culture of the '60s, many people wanted to believe that the province was paradise. While 'ambitious' artists on the prairies struggled to understand the rules of the game, Vancouver's artists self-confidently kept up with the times.[1] The heady scent of liberation — liberation from Canada's constipated, conservative past — was in the air. The 'older generation' streamlined its styles, and the highly individualistic younger one carried the day.

There were, of course, some problems with this myth. Life in British Columbia was not always wonderful, and Vancouver's moment of artistic sunshine was short-lived — about fifteen minutes, as Andy Warhol might have predicted.

What happened? In 1960, Jack Shadbolt was king of the mountain, and nature derived abstraction was still the order of the day. But the next generation of artists were tired of these homages to nature, and few of them made anything new of them.

Ann Kipling was one who did. A 1960 graduate of the Vancouver School of Art, she had developed a highly original response to nature by 1964, when she was living in Lynn Valley in North Vancouver. Working from point to point, moving from a branch, to a cloud, to a rock face, she drew the mountains around her. The results look much like gestural abstractions at first, for she wove everything together and avoided continuous contours that might separate the elements in her works. But there was nothing arbitrary or consciously stylized about these delicate drawings. They are empirical records of the shifting process of vision and Kipling's changing relationship to her environment.

Toni Onley also found inspiration in the Coastal landscape. He moved from tightly hatched drawings and etchings that were influenced by Giorgio Morandi towards Oriental simplicity and balance in the broadly washed watercolours and screenprints of the late '60s. His abstract paintings and collages underwent this reductive transformation even earlier, however, moving towards 'one note' simplicity by the early '60s. Like many Vancouverites, Onley smelled Japan in the fragrant sea air. He gained a large public following and helped to reinforce the image of Vancouver's art scene as stylish and sophisticated.

1) Population in 1961: 384,522.

Ann Kipling
Untitled (Lynn Valley),
1964
ink on paper
30 x 73.5 cm.
Collection of the artist,
Falkland, B.C.

Michael Morris
*The Problem of
Nothing,* 1966
acrylic on canvas
137.2 x 152.4 cm.
Collection of The Vancouver
Art Gallery
(not included in the exhibition)

Roy Kiyooka, who was of Japanese ancestry, furthered this romance with the Orient — a romance that F.H. Varley had encouraged during the '30s, but that had nearly died during the war. He preached Zen openness and spontaneity to his students at the Vancouver School of Art, and erratically moved from one style to another until he chose the ellipse and a symmetrical 'hard edge' format in 1964. The paintings that followed still distantly echoed some of Ronald Bloore's layouts, but they were even 'cooler' and more iconic.

Kiyooka's influence at the art school was as great as Shadbolt's had been in the '50s. The evidence of this can be seen in Brian Fisher's huge acrylics. With initial encouragement from Bloore, who visited him in Vancouver, he began to enlarge his rapidograph mandala drawings into paintings in 1963-64.[2] The paintings of the next few years often followed Kiyooka's symmetrical double ellipse format. With their crisp linear patterns and close valued colour relations, they played optical kinetics off against rigid geometric formats.

Michael Morris toyed with 'hard edge' abstraction as well, but was much more careless about his technique. His loosely brushed 'monument' paintings of 1964 show what a gift he possessed for the painterly. No wonder most of the bars and stripes that followed have the wobbly, irregular look of art that does not really want to stand in line.

2) Brian Fisher to Christopher Varley, October 18, 1982

Roy Kiyooka
Shahu No. 2, 1964
acrylic on canvas
226.7 x 150.5 cm.
Collection of the
University of Calgary at
the Nickle Arts Museum

Iain Baxter
Vegetables, 1965
vacuum plastic
81 x 95.5 x 5 cm.
Collection of the Art Gallery
of Greater Victoria. Given to
Colin Graham Retirement
Fund Auction

Brian Fisher
Beacon, 1966
acrylic on canvas
172.7 x 287 cm.
Collection of The Edmonton
Art Gallery

Toni Onley
Reach, 1964
oil on canvas
132.1 x 152.4 cm.
Lent by Kenneth G. Heffel
Fine Art Inc., Vancouver

Maxwell Bates
*View from Pandora's
Box,* 1968
oil on canvas
61 x 76.2 cm.
Collection of the Mendel Art
Gallery, Saskatoon

Gordon Smith
Untitled (Banff Series),
n.d.
acrylic on canvas
61 x 76.2 cm.
Collection of Jeffrey
Spalding, Lethbridge

Morris made something of a name for himself before graduating from the Vancouver School of Art in 1964. He was a brilliant, prolific student who scattered his shots far and wide, and gave the teachers a run for their money. From 1964 to 1966 he continued post-graduate level studies at the Slade School in London. There he became better acquainted with British pop art, and fell under the influence of Eduardo Paolozzi, who was known for his use of readymades and parodies of modern industrial production. In the paintings and prints that followed, Morris often satirized the pretentions of 'high art'. He placed huge aluminum frames around some stripe paintings, as if to make them look more important, and made flippant allusions to the previously eulogized Coastal landscape in others.

But the real 'ideas' man in Vancouver was Iain Baxter, who began teaching at the University of British Columbia in 1964. His vacuum formed plastic 'still lifes' and 'bagged landscapes' of the mid-'60s comment on — what else? — our 'packaged' society. They seem more Californian than Canadian in their upbeat cheerfulness, and in the mock-documentations that followed, Baxter unapologetically cribbed ideas from that subtle satirist of pop and conceptual art, Los Angeles artist Ed Ruscha. As president of the N.E. Thing Company, he marketed his wares as if they were so much toothpaste or soap.

The Vancouver Art Gallery reinforced this American connection with exhibitions like *Los Angeles 6* of April 1968 (in which Ruscha was included), and *New York 13* of January 1969, as well as by purchasing artworks by Robert Irwin, John McCracken, Claes Oldenburg, Frank Stella, and others. Richard Simmins deserves much of the credit for this, although he was no longer associated with the Gallery at the time that these events took place. When he was appointed director in 1963 the Gallery's fortunes were at a very low ebb. But he brought to the job the same enthusiasm that had

catapulted *Regina Five* off to such a jolting start two years before, and he was soon pulling in crowds and memberships with a broadly appealing and frequently challenging exhibition program. It was Doris Shadbolt, the Senior Curator, however, who provided the continuity and much of the talent that the gallery needed. The gallery threw open its doors to the younger artists in the city, and developed an exhibition and special events program that was open to all aspects of contemporary art. In the heady days of the late '60s, the distinction between 'high art' and life looked arbitrary and pointless. So why not forget the 'problem' and take the creative process out into the world? In such a climate, painting began to seem a slow and irrelevant procedure. Many of Vancouver's artists put away their brushes.

The older generation were, of course, caught by surprise. Some struggled to catch up; others disappeared from sight. One who successfully adapted to the times was Gordon Smith. His geometric screenprints and 'hard edge' acrylic abstractions were widely collected.

There was a darker side to the picture though, for Vancouver was also 'Terminal City' — the end of the rainbow and the land of shattered dreams. Maxwell Bates, who moved to Victoria from Calgary in 1962, ridiculed the foolishly-dressed tourists who stampeded to British Columbia in search of 'the good life'. He countered the provincial government's endless boosterism with irony, and was greatly respected by his colleagues in both Victoria and Vancouver for his tough, implacable stance. He did not like the 'packaged' society, and all his paintings had a pointedly rough-hewn look about them.

There were also strong expressionist undercurrents in Vancouver. Claude Breeze gained national attention and local notoriety with his brilliantly coloured, broadly brushed figure paintings

Marianna Schmidt
In Spring, 1965
etching and aquatint on
paper
75.2 x 50.2 cm. (image size)
Collection of The Edmonton
Art Gallery. Purchased in
1966

Richard Turner
Observatory, 1965
etching on paper 14/100
17 x 27 cm. (image size)
Collection of Dr. Kenneth
Morton, Vancouver

of violence and sexual conflict. Marianna Schmidt's etchings were filled with the maniacal whimsy of Jean Dubuffet's *art brut*. Richard Turner produced enigmatic images with sado-masochistic overtones. All three artists presented man as an irrational creature driven by instinct to actions which were usually stupid or cruel.

Vancouver's scene was therefore marked by strong contrasts, great independence, and lots of nerve. For a few years there seemed to be enough room for everybody. Breeze, Kiyooka, Morris, and Onley all had their followers.

But public support could hardly be described as overwhelming. Many citizens began to resent The Vancouver Art Gallery's strong emphasis on contemporary art. Until the late '60s, the Fine Arts Gallery that Alvin Balkind ran at the University of British Columbia was the only other serious forum for contemporary art.

Then co-operative groups such as Intermedia began to emerge. With Canada Council support, these grew into a tradition during the following decade. But the close community of the mid '60s was now divided, and the artists have lived in increasing isolation from one another ever since.

Perhaps the '60s marked Vancouver's coming of age, for pluralism is the obvious hallmark of a cosmopolitan society. And yet nothing much has happened since then, suggesting that the growth of the Vancouver scene was too fast for its shallow root system to support. There was no continuity from one generation to the next. The second built on the first as if the first was simply so much sediment. But sooner or later this sediment will harden into something stronger, and we will undoubtedly hear of Vancouver again.

Claude Breeze
*Grass, Sky and Trees
No. 2,* 1966
acrylic on canvas
178 x 117 cm.
Collection of the Canada
Council Art Bank, Ottawa

Summary _____

The post-war development of art in western Canada was largely dependent upon the existence of educational and cultural institutions. Without the teaching jobs and the leadership of some public art galleries, the history of this period would have been entirely different, for private patronage was almost non-existent, and the artists and general public had few natural points of contact.

But institutions are only as good as the people who run them, and there were certainly instances of the wrong people making the wrong moves. Entrenchment was also always a potential problem, for secure employment was a luxury that many artists and cultural bureaucrats wished to protect.

The north-south axis that we so often hear about certainly existed. Many artists took their training in The United States, or maintained contact with Chicago or California. There was surprisingly little travel to or from the East. Toronto maintained most of its own contacts with New York. Western fears of cultural domination appear to have been as unfounded as eastern presumptions of cultural hegemony.

The West may have been more alienated from eastern Canada fifteen years ago than it is today, for most successful artists now have dealers in Toronto or Montreal, and at least fly east for the openings of their exhibitions. The recent increase in feelings of isolation stems in part from the fact that so few large group exhibitions of contemporary art now travel back and forth across the country, and because there are no longer any national art magazines. We have fewer and fewer opportunities to see what Toronto or Halifax is doing in our own home towns.

The most extraordinary characteristic of the post-war period was the extent to which much of the culture was home grown. Most of the artists in this exhibition grew up in the West. Some never lived anywhere else. Most of their movements were within the region.

But western Canada can hardly be called a region, for it is enormous, and contains many geographic and cultural divisions. The six cities discussed here are not only hundreds of miles apart, they also look toward different directions. Vancouver had no truck with Chicago, and Winnipeg knew little of what was going on in San Francisco. Likewise, the four provinces tended to part in the middle, with Calgary looking west towards Vancouver and the Coast, Saskatoon looking towards Winnipeg, and Regina looking to points beyond in the eastern United States.

Perhaps this exhibition should have been entitled *Endless False Starts*, for with the rather tame exception of Saskatoon, and the virtual 'no show' of Edmonton, the other four cities had some real ups and downs during the period in question. They lacked the continuity of traditions. But these do not grow overnight, and in cities so small that four or five artists may constitute most of the community, a misunderstanding or personal difference can bring the whole house down. Until these cultural islands grow some more we should not anticipate that they will always capitalize on their strengths. Greater depth of commitment, tolerance, pluralism, and wider public support are all still required.

Christopher Varley
July 7, 1983

Selected Bibliography of Contemporary Publications

Ayre, Robert; "The Saskatchewan Arts Board" *Canadian Art*, Vol. XI, No. 1, Autumn 1953

Ayre, Robert; "Lionel LeMoine FitzGerald, 1890-1956" *Canadian Art*, Vol. XIV, No. 1, Autumn 1956

Ballantyne, Michael; "A New Deal for the Vancouver Art Gallery" *Canadian Art*, Vol. XXII, No. 2, March-April 1965

Bates, Maxwell; "Some Problems of Environment" *Highlights*, Vol. 2, No. 8, December 1948

Bates, Maxwell; "Art and Snobbery" *Highlights*, Vol. 1, No. 1 (sic), March 1949

Bates, Maxwell; "The Flight from Meaning in Painting" *Canadian Art*, Vol. XI, No. 2, Winter 1954

Bates, Maxwell; "Some Reflections on Art in Alberta" *Canadian Art*, Vol. XIII, No. 1, Autumn 1955

Bates, Maxwell; "Divided We Fall" *Highlights*, Summer 1957

Binning, B.C.; "The Teaching of Drawing" *Canadian Art*, Vol. V, No. 1, October-November 1947

Bloore, Ronald L.; "The Prairies: 'to assert man's presence'" *Artscanada*, Vol. XXVI, No. 6, December 1969

Bornstein, Eli; "Notes on Structurist Vision" *Canadian Art Today*, Studio International, London, 1970

Buchanan, Donald W.; "Shadbolt Explores a World of Roots and Seeds" *Canadian Art*, Vol. VIII, No. 3, Spring 1951

Buchanan, Donald W.; "Prairie Metamorphosis" *Canadian Art*, Vol. XI, No. 1, Autumn 1953

Buchanan, Donald W.; "A Prairie Approach to a Canadian Vision" *Canadian Art*, Vol. XX, No. 1, January-February 1963

Dillow, Nancy E., and Terry Fenton; *Saskatchewan: Art and Artists* (exhibition catalogue) Norman MacKenzie Art Gallery and Regina Public Library Art Gallery, April 2-July 31, 1971

Eastman, Alvin C.; "The Winnipeg Art Gallery" *Canadian Art*, Vol. X, No. 2, Winter 1952-53

Eckhardt, Fernand; *150 Years of Art in Manitoba: Struggle for a Visual Civilization* (exhibition catalogue) Winnipeg Art Gallery, May 1-August 31, 1970

Eckhardt, Fernand; "The Technique of L.L. FitzGerald" *Canadian Art*, Vol. XV, No. 2, April 1958

Emery, Anthony; "Gordon Smith and the Gesture of Painting" *Canadian Art*, Vol. XIV, No. 1, Autumn 1956

Emery, Anthony; "Ronald Spickett: Symbol of the Real" *Canadian Art*, Vol. XVII, No. 4, July 1960

Emery, Anthony; "Gordon Smith" *Canadian Art*, Vol. XXIII, No. 3, July 1966

Fenton, Terry; "Introduction" *Painting in Saskatchewan, 1883-1959* (exhibition catalogue) Norman MacKenzie Art Gallery, October 6-November 5, 1967

Fenton, Terry; "Olitski and Saskatchewan" *Norman MacKenzie Art Gallery* (newsletter), April 1970

Fenton, Terry; "Abstraction West: Emma Lake and After" *Journal*, The National Gallery of Canada, No. 11, March 1, 1976

FitzGerald, L.L.; "FitzGerald on Art" *Canadian Art*, Vol. XV, No. 2, April 1958

Fulford, Robert; "Bruno Bobak" *Canadian Art*, Vol. XVIII, No. 1, January-February 1961

Fulford, Robert; "Don Jarvis" *Canadian Art*, Vol. XVIII, No. 1, January-February 1961

Fulford, Robert; "Lochhead" *Canadian Art*, Vol. XVIII, No. 1, January-February 1961

Fulford, Robert; "Smith" *Canadian Art*, Vol. XVIII, No. 1, January-February 1961

Fulford, Robert; "Spickett" *Canadian Art*, Vol. XVIII, No. 1, January-February 1961

Graham, Colin; "A Year in the Sun" *Canadian Art*, Vol. XV, No. 2, April 1958

Gray, John; " A Paintbrush Sweeps Vancouver" *The Star Weekly*, Toronto, July 2, 1960

Greenberg, Clement; "Clement Greenberg's View of Art on the Prairies: Painting and Sculpture in Prairie Canada Today" *Canadian Art*, Vol. XX, No. 2, March-April 1963

Groves, Naomi Jackson; "Five Painters From Regina: at the National Gallery of Canada, Ottawa" *Canadian Art*, Vol. XIX, No. 2, March-April 1962

Harper, Russell; *Painting in Canada: A History* University of Toronto Press, Toronto, 1966

Harris, Lawren; "LeMoine FitzGerald — Western Artist" *Canadian Art*, Vol. III, No. 1, October-November 1945

Harris, Lawren; "An Essay on Abstract Painting" *Canadian Art*, Vol. VI, No. 3, Spring 1949

Harris, Lawren; "What the Public Wants" *Canadian Art*, Vol. XI, No. 1, Autumn 1954

Hubbard, R.H.; "A Climate for the Arts" *Canadian Art*, Vol. XII, No. 4, Summer 1955

Hubbard, R.H.; "The Arts in Saskatchewan Today" *Canadian Art*, Vol. XII, No. 4, Summer 1955

Hubbard, R.H., and J.R. Ostiguy; *Three Hundred Years of Canadian Art* (exhibition catalogue) The National Gallery of Canada, Ottawa, 1967

Hudson, Andrew; "Memories of Saskatchewan" *Canadian Art Today*, Studio International, London, 1970

Hughes, E.J.; "My Impressions When Viewing Nature" *Canadian Art*, Vol. XIII, No. 4, Summer 1956

Jackson, A.Y.; "Banff School of Fine Arts" *Canadian Art*, Vol. III, No. 4, July 1946

Jackson, A.Y.; *Abstract Painting* Rous & Mann Press Limited, Toronto, 1954

Kerr, Illingworth; "Maxwell Bates, Dramatist" *Canadian Art*, Vol. XIII, No. 4, Summer 1956

Key, A.F.; "The Calgary Art Centre" *Canadian Art*, Vol. IV, No. 3, May 1947

King, John; *A Documented Study of the Artists' Workshop at Emma Lake, Saskatchewan of the School of Art, University of Saskatchewan, Regina, from 1955 to 1970* B.F.A. thesis, University of Manitoba, 1970

Lasserre, Fred; "Regional Trends in West Coast Architecture" *Canadian Art* Vol. V, No. 1, October-November 1947

Lee, Roger; *The Theories of Hans Hofmann and Their Influence on his West Coast Canadian Students* M.A. thesis, University of British Columbia, 1966

Lord, Barry; "Ronald Bloore and contemporary art criticism" *Canadian Art*, Vol. XXIII, No. 4, October 1966

Macdonald, J.W.G.; "Heralding a New Group" *Canadian Art*, Vol. V, No. 1, October-November 1947

McCullough, Norah; "The Norman MacKenzie Art Gallery and the School of Art" *Canadian Art*, Vol. XV, No. 3, August 1958

McKay, Arthur; "Emma Lake Artists' Workshop: An Appreciation" *Canadian Art*, Vol. XXI, No. 5, September-October 1964

McNairn, Ian; *7 West Coast Painters* (exhibition catalogue) Fine Arts Gallery, University of British Columbia, 1959

Newton, Eric; "Canadian Art in Perspective" *Canadian Art*, Vol. XI, No. 3, Spring 1954

Nicoll, J. McL.; "Alberta Hangs Up Its Chaps" *Jubilee Exhibition of Alberta Paintings* (exhibition catalogue) Calgary Allied Arts Centre, Coste House, Calgary, June 19-September 18, 1955

One Hundred Years of B.C. Art (exhibition catalogue) The Vancouver Art Gallery, 1958

Plaskett, Joseph; "Some New Canadian Painters and Their Debt to Hans Hofmann" *Canadian Art*, Vol. X, No. 2, Winter 1952-53

Rogatnick, Abraham; "Roy Kiyooka" *Canadian Art*, Vol. 19, No. 2, March-April 1962

Scott, Charles H.; "New Tides in West Coast Art" *Canadian Art*, Vol. VII, No. 2, Christmas-New Year 1949-50

Shadbolt, Doris; "The Vancouver Art Gallery" *Canadian Art*, Vol. VI, No. 1, Autumn 1948

Shadbolt, Doris; "Molly and Bruno Bobak" *Canadian Art*, Vol. IX, No. 3, Spring 1952

Shadbolt, Doris; "Ed Hughes — Painter of the West Coast" *Canadian Art*, Vol. X, No. 3, Spring 1953

Shadbolt, Doris; "New Life to Graphic Art on the West Coast" *Canadian Art*, Vol. XII, No. 2, Winter 1954-New Year 1955

Shadbolt, Doris; "Joe Plaskett — An Ode to a Room" *Canadian Art*, Vol. XIII, No. 4, Summer 1956

Shadbolt, Doris; "B.C.'s New Talent Show to Tour Canada" *Canadian Art*, Vol. XXI, No. 5, September-October 1964

Shadbolt, Doris; "The Vancouver Scene" *Canadian Art Today*, Studio International, London, 1970

Shadbolt, Jack; "A Report on Art Today in British Columbia" *Canadian Art*, Vol. IV, No. 1, November-December 1946

Shadbolt, Jack; "Recent British Columbia Paintings and the Contemporary Tradition" *Royal Architectural Institute of Canada Journal*, Vol. 28, No. 112, December 1951

Shadbolt, Jack; "The Note-books of Donald Jarvis" *Canadian Art*, Vol. X, No. 1, October 1952

Silcox, David; "Canadian Art in the Sixties" *Canadian Art*, Vol. XXIII, No. 1, January 1966

Simmins, Richard B.; *Five Painters from Regina* (exhibition catalogue) The National Gallery of Canada, 1961

Simmins, Richard B.; "Ronald L. Bloore" *Canadian Art*, Vol. XIX, No. 2, March-April 1962

Simmins, Richard B.; "Ted Godwin" *Canadian Art*, Vol. XIX, No. 2, March-April 1962

Simmins, Richard B.; "Arthur McKay" *Canadian Art*, Vol. XIX, No. 2, March-April 1962

Spickett, Ronald; "A Kind of Order" *Highlights*, Autumn 1959

Swinton, George; "The Great Winnipeg Controversy" *Canadian Art*, Vol. XIII, No. 2, Winter 1956

Thomas, Carin Thyra; *A Survey of Art in Edmonton in the 1960s: Trends and Attitudes*, M.E. thesis, Central Washington State College, August 1970

Thompson, David; "A Canadian Scene" *Studio International*, Vol. 176, No. 90, October 1968

Townsend, Charlotte; "The N.E. Thing Co., and Les Levine" *Canadian Art Today*, Studio International, London, 1970

Townsend, William; "Notes: by way of introduction and dedication" *Canadian Art Today*, Studio International, London, 1970

Williams, Richard; "Ivan Eyre" *Canadian Art*, Vol. XXI, No. 1, January-February 1964

Withrow, William; *Contemporary Canadian Painting* McClelland and Stewart Limited, Toronto, 1972

Publication: _____

Text: *Christopher Varley*
Art Direction/Design: *Monty Cooper*
Editing: *Deborah Witwicki*
Typesetting:*Threeway Graphic Services Ltd.*
Colour Separations/B&W Halftones: *BK Trade Colour
 Separations Ltd.*
Printing: *Cliff and Watters Lithographing Co. Ltd.*
Photography:

Art Gallery of Greater Victoria: p. 8 (right), p. 52 (right)
Art Gallery of Ontario: p. 38
Audio Visual Services, University of Regina: p. 40, p. 42, p. 43 (left), p. 44 (middle), p. 46 (top)
Yvan Boulerice: p. 35 (left), p. 48 (top right), p. 55
Creative Professional Photographers Ltd.: p. 15, p. 16, p. 43 (right), p. 44 (top), p. 45 (top), p. 46 (bottom), p. 47,
 p. 48 (top left and bottom right), p. 53 (left)
Edmonton Art Gallery: p. 22
Galerie Dresdnere (Toronto) Ltd.: p. 32
Gallery/Stratford: p. 7
Glenbow Museum: p. 20, p. 24 (bottom), p. 25, p. 28, p. 37 (left and right)
Jim Gorman: p. 50 (bottom)
Tod Greenaway: opposite p. 1, p. 3, p. 5, p. 51 (bottom), p. 54 (right)
Eleanor Lazare: p. 4 (top), p. 6, p. 8 (left), p. 9, p. 10, p. 12, p. 21 (top and bottom), p. 24 (top), p. 26, p. 27 (top and
 bottom), p. 30, p. 31 (top), p. 33 (bottom), p. 39, p. 44 (bottom), p. 45 (bottom), p. 50 (top), p. 51 (top), p. 53
 (right), p. 54 (left)
Ernest Mayer: front cover, p. 13, p. 14 (top and bottom), p. 17, p. 18, p. 23
Moose Jaw Art Museum and National Exhibition Centre: p. 33 (top)
Douglas Morton: p. 34
National Gallery of Canada: p. 31 (bottom)
Victor Sakuta: p. 35 (right)
Sarnia Public Library and Art Gallery: p. 2
Seattle Art Museum: p. 4 (bottom)
University of Calgary: p. 52 (left)

ISBN 0-88950-037-1

*The Edmonton Art Gallery is a registered, non-profit organization supported by
its members and donors, and by grants from the City of Edmonton, Alberta
Culture, The Canada Council and the Museums Assistance Programmes of the
National Museums of Canada.*

The Edmonton Art Gallery
2 Sir Winston Churchill Square
Edmonton, Alberta, Canada
T5J 2C1

(403) 422-6223